SECRET DUMFRIES

Mary Smith & Keith Kirk

AMBERLEY

Dedicated to Caroline Kirk and Jon Gibbs-Smith for all their support

First published 2018

Amberley Publishing
The Hill, Stroud
Gloucestershire, GL5 4EP

www.amberley-books.com

Copyright © Mary Smith & Keith Kirk, 2018

The right of Mary Smith & Keith Kirk to be
identified as the Authors of this work has been
asserted in accordance with the Copyrights, Designs
and Patents Act 1988.

ISBN 978 1 4456 7498 8 (print)
ISBN 978 1 4456 7499 5 (ebook)

British Library Cataloguing in Publication Data.
A catalogue record for this book is available from the
British Library.

Origination by Amberley Publishing.
Printed in Great Britain.

Contents

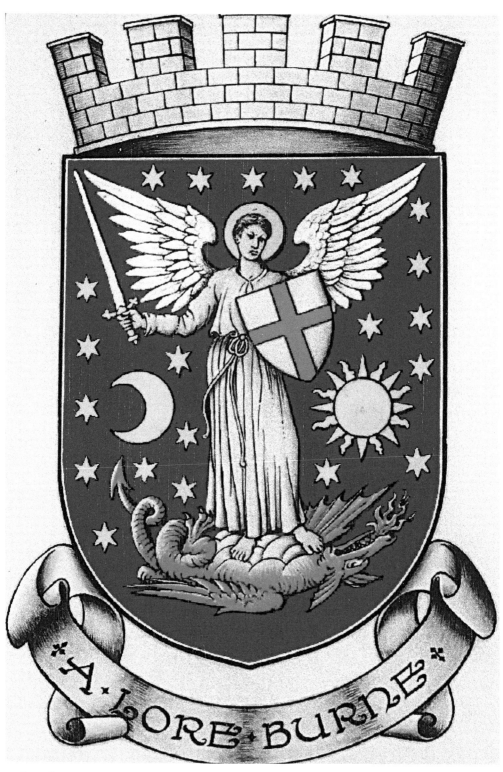

Coat of arms.

Introduction

Dumfries is a market town situated on the River Nith, which regularly bursts its banks, flooding part of the town as it flows on its way to the Solway Firth. It is known as the 'Queen of the South', a name given to it by local poet David Dunbar, not in a poem but in a speech he made when standing as a candidate in the 1857 General Election.

People who are born and bred in the town are called Doonhamers. The expression came about when people from Dumfries worked in the factories in Strathclyde during the war. At the weekend they would say they were going 'doon hame' (down home) and the name stuck.

Much has been written about Dumfries, its history, trades and markets and about the famous people with connections to the town. Chief of those must be Scotland's bard, Robert Burns. Dumfries is a Mecca for Rabbie enthusiasts. His statue stands proudly in the town centre. The house where he died is a museum containing many original letters, manuscripts and the chair in which he sat to write his poems. A few miles away is Ellisland, where he farmed and in the town are pubs where he drank, the theatre he frequented, the church where he worshipped and the mausoleum where he is buried.

Author J. M. Barrie lived for five years in Dumfries, attending the Academy. He spent much of his free time playing in the garden of Moat Brae, which he acknowledged as the inspiration for the setting of Peter Pan.

So far, all so well known. What secrets about Dumfries would we be able to find? Of course, almost nothing is completely secret nowadays but, as with most places, there are more than a few surprises to be unearthed. While many people know about the Arrol-Johnston car factory in the town, perhaps not so many are aware that Malcolm Campbell's land speed record-holding *Bluebird* was rebuilt here in 1928.

We have enjoyed learning about some amazing people with connections to the town: Miss McKie, the first and only woman to be given the Freedom of the Burgh; Blin' Tam the bell-ringer; and Patrick Miller, who possibly introduced the swede to Scotland.

In some ways, Dumfries is a town of firsts: the first anaesthesia used in surgery, the first nursing lectures delivered, the first steamboat and the first savings bank in the world. It is also a town of lasts: the last public hangings in Scotland, and the last witch trial.

We hope readers, whether Doonhamers or visitors, will enjoy *Secret Dumfries* and that it will tempt them to explore further.

Welcome to Dumfries.

1. History

Archaeological finds indicate nomadic hunters were beginning to settle in the area over 8,000 years ago. Then, the first farmers came with their knowledge of growing crops and ability to make pottery.

Later, around 2300 BC, more hunters and herdsmen arrived. They are referred to as the Beaker people because they buried small drinking vessels with their dead. These were the people who heralded the Bronze Age. They left evidence in the form of bronze axes, daggers and swords and also stone tools and weapons of war. Burial customs changed from burial of the body in a stone cist to cremating the dead and burying their ashes in pottery urns. A number of urn burials have been found in and around what came to be called Dumfries.

Iron Age forts appeared on the Midsteeple Hill and Chapel Hill and other sites. The Romans came and went. Dumfries came under Welsh rule then Northumbrian. The Ruthwell Cross, which Alf Truckell describes in the preface to McDowall's *History of Dumfries* as 'that great symbol of the power of the Northumbrian Empire and of the Church of Rome', was erected between AD 650 and AD 700.

In 1186 Dumfries was made a Royal Burgh by William the Lion, which gave the townspeople the right to elect their own town councils and raise local taxes and rates. The town continued to expand along the east bank of the River Nith. It was very much a frontier town as the land across the river to the west was the Kingdom of Galloway, which remained independent of Scotland until the 1230s.

DID YOU KNOW THAT...?

The crest of Dumfries contains the words 'A Lore Burne'. Close to the town was the marsh through which ran the Loreburn, whose name became the rallying cry of the town in times of attack – 'A Lore Burne', meaning 'to the muddy stream'.

Dumfries had a tough time over the following centuries. Being so close to the border with England led to it being occupied, plundered and sacked on several occasions. It was also the place in which Scottish history was irrevocably changed – even if it might have been by accident. When Queen Margaret died in 1290 there was no heir to the Scottish throne, with various factions of the nobility claiming kingship. By 1306 the main contenders were Robert the Bruce and John 'The Red' Comyn. On 10 February Bruce and Comyn met in the chapel of the Greyfriars Monastery.

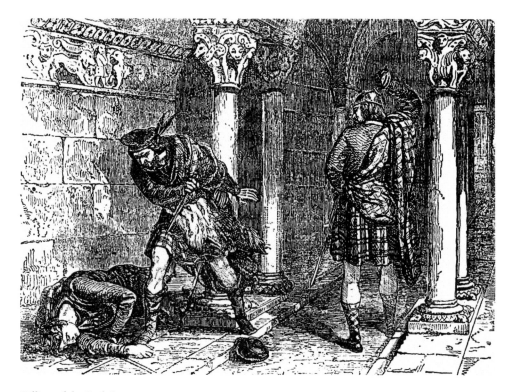

Killing of the Red Comyn.

We don't know why the two met or what was said. One theory is that Bruce had earlier suggested he and Comyn unite against Edward I. During their meeting Bruce discovered Comyn had told the English king of the plan, lost his temper, pulled out his dagger and stabbed Comyn. He rushed from the church, saying, 'I must be off, for I doubt I have slain the Red Comyn.'

Kirkpatrick of Closeburn answered, 'You doubt? I mak siccar' (I'll make sure), rushed into the church and finished the job. On 25 March 1306 Bruce was crowned King of Scotland. He was also excommunicated by the Pope, not so much for killing Comyn but for committing sacrilege by doing it in a church. However, Bishop of Glasgow Robert Wishart, a supporter of both William Wallace and Bruce, gave him absolution. 'I mak siccar' became the motto of the Kirkpatrick family.

Sir Christopher Seton, the husband of Bruce's sister, Christian (or Christiana), was present at the killing of the Red Comyn. He killed Comyn's uncle when he made to attack Bruce. Soon after, Seton was captured, along with his brothers John and Humphrey, at Loch Doon Castle. They were taken to Dumfries where they were hanged, drawn and quartered on what became known as Gallows Hill. Christian Bruce erected a Chapel to the Holy Rood, known as the Crystal Chapel, on the site in memory of her husband. It stood on a small hill where its remains could still be seen until the 1830s when St Mary's Church was built on the site. Part of the chapel was demolished when dressed stones were needed to build defences against the arrival of the Jacobites in 1715.

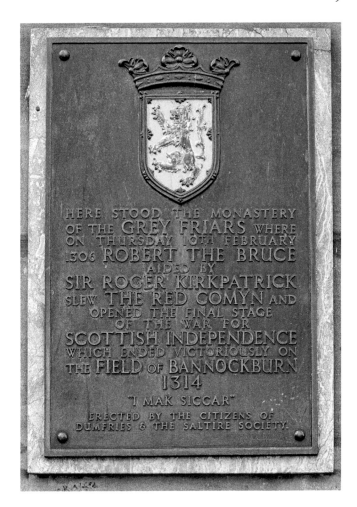

HERE STOOD THE MONASTERY
OF THE GREY FRIARS WHERE
ON THURSDAY 10TH FEBRUARY
1306 ROBERT THE BRUCE
AIDED BY
SIR ROGER KIRKPATRICK
SLEW THE RED COMYN AND
OPENED THE FINAL STAGE
OF THE WAR FOR
SCOTTISH INDEPENDENCE
WHICH ENDED VICTORIOUSLY ON
THE FIELD OF BANNOCKBURN
1314
"I MAK SICCAR"
ERECTED BY THE CITIZENS OF
DUMFRIES & THE SALTIRE SOCIETY.

Right: Plaque on the site of the monastery.

Below: Sign on Greyfriars Street – another Comyn reminder.

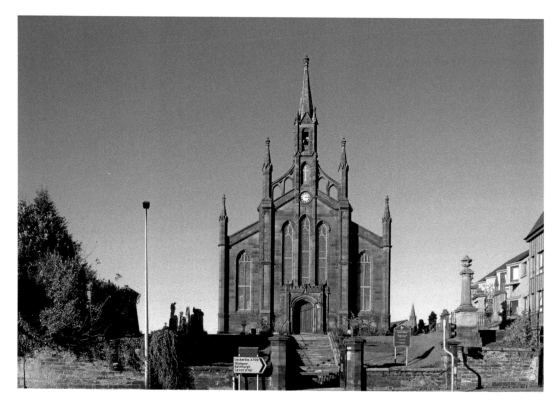

St Mary's Church.

Around 300,000 Scots signed the National Covenant in 1638, petitioning King Charles I to allow the Presbyterian Church in Scotland to be free from interference. This led to the persecution of the Covenanters, which escalated during the reign of Charles II. Many were hunted down and killed during The Killing Times and are commemorated throughout the region. James Kirko was shot on the Whitesands, Dumfries in 1685.

Bonnie Prince Charlie arrived in Dumfries in December 1745 on his retreat from Derby. In September he had sent the town council a tax demand, which was ignored. Demonstrating that there is little new in local government, when a second demand arrived the council set up a committee to consider it.

Richard Lowthian provided Charles with a room in his townhouse from where he demanded a fine of £2,000 plus 1,000 pairs of shoes and all the arms held in the town – by 8 p.m. the following evening. Lowthian's house has since been the Blue Bell Inn, the Commercial Hotel and then the County Hotel. Now, only the façade is left of the magnificent eighteenth-century building.

The shoes were desperately needed as many of his soldiers were practically barefoot. By 3 p.m. only 255 pairs had been collected and £1,195. On hearing (mistakenly) that the Duke of Cumberland had captured Carlisle and was marching towards them, Charles left Dumfries the next morning, without the full number of shoes or the money but taking two hostages who were released only when the rest of the money was paid.

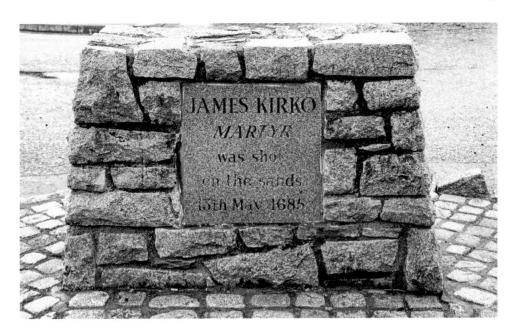

Above: James Kirko's monument on the Whitesands.

Right: Bonnie Prince Charlie's HQ, now Waterstones.

It is surprising Dumfries could only come up with 255 pairs of shoes because shoemaking was an important trade. In 1832, the shoemakers' guild had a membership of 300. By the 1400s, the town's craftsmen had organised themselves into guilds. Their elected leaders, deacons, became members of the town council along with the merchants, who were the wealthiest citizens. Originally, there were eleven incorporated crafts: smiths, wrights and masons, websters, tailors, shoemakers, skinners and glovers, fleshers, armourers, pewterers or tinsmiths, bonnet makers and dyers. These were later reduced to seven Incorporated Trades, each with its own flag.

DID YOU KNOW THAT…?

The town's executioner was allowed to take a ladleful of grain from each sack in the meal market. In the 1700s the merchants were annoyed with this and one, John Johnston, stopped executioner Rodger Wilson from taking meal. Wilson appealed to the town and Mr Johnston took legal action against the town council. In 1789 executioner Joseph Tait asked the council for a pay rise, complaining he wasn't allowed his meal. He received a small wage increase but was told he'd have to raise an action against the merchants. No solicitor would take on his case and the custom ended.

A craftsman served a five-year apprenticeship followed by an exam. If successful, he was allowed to join the guild and was recognised as a freeman of the burgh. In return, he had to be ready to defend the burgh by showing competency in shooting. To this end James VI of Scotland and I of England presented the Trades with a trophy – the siller gun – to be awarded in an annual shooting competition.

Originally the gun probably took the form of a miniature cannon mounted on a wheeled carriage. It was broken in 1808 and remodelled to give the appearance of a flintlock musket. The person who broke the siller gun was fined and banished from associating with his trade for twenty-one years. The competition for the siller gun continues in Dumfries during the annual Guid Nychburris Week, though the winner receives a medal and the siller gun is kept in Dumfries Museum.

The Seven Trades was a powerful body with many rules and regulations and total control over the production and sale of everything. Infringements could result in fines, imprisonment or banishment, and the loss of burgess rights. They also set the price of goods for sale from candles to suits of clothing and cloth had to be measured using yardsticks calibrated on the Dumfries foot. Corn could only be ground in the town's mills and no ground grain was allowed into the town. The Seven Trades moved into a new Trades Hall, built above the meal market, in June 1806. To celebrate, convenor Robert Grainger bought a huge punchbowl, which was refilled many times as over 100 gentlemen proposed toasts and replies.

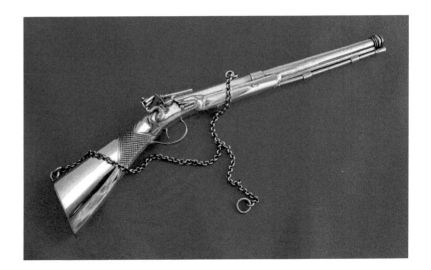

Right: Siller gun.

Below: Trades Hall.

It was soon after this that the power of the Seven Trades came to an end. An 1846 Act of Parliament banned their privileges as a restriction of free trade. The historical relics were auctioned, including the magnificent punchbowl. Gradually, the Dumfries Museum has been able to acquire most of these artefacts.

Dumfries grew on the east side of the River Nith. Across Devorgilla Bridge lay the small village of Bridgend (or Brigend), which was in the Stewartry of Kirkcudbright and not

Restoration plaque on Trades Hall.

under Dumfries jurisdiction. The nearest authorities were 20 miles away. As a result it gained a reputation as a hiding place for criminals.

Things began to change in 1810 when Marmaduke, Constable Maxwell of Terregles, obtained a charter from the Crown, which made the village into a free Burgh of Barony called Maxwelltown. With the adoption of the Police Act in 1833, it was able to raise money to improve paving, street lighting and cleaning the streets. Small industries started up: a brewery, tanneries, weaving, sawmills and iron foundries. The huge Troqueer and Rosefield Mills were built, bringing further prosperity. By 1900 it had become one of the biggest burghs in south-west Scotland and in the 1920s led the way in Scottish social welfare with a radical new housing scheme.

At first, there was a huge resistance to amalgamation with Dumfries. The proposal was overwhelmingly defeated in a referendum in 1927. However, the Local Government (Scotland) Act of 1929 intended to remove the right to local autonomy from burghs with populations of less than 20,000. Dumfries would acquire powers from the county council but Maxwelltown would have to give up some if its powers. With reluctance the union was agreed and the two burghs amalgamated on 3 October 1929. The Duke of Buccleuch presided over the ceremony on St Michael's Bridge.

St Michael's Bridge.

Above left: Dumfries crest on bridge.

Above right: Maxwelltown crest on bridge.

It is often the smaller details which make history come alive and allow us a glimpse into what life in Dumfries was like. Alf Truckell, writing in the preface to the 1928 edition of McDowall's *History of Dumfries*, provides a colourful and somewhat startling account of events in the year 1607, taken from the town's Privy Council records.

A man tries to strangle a boy with a garter and throws him in the Mill Dam in March: the King's messenger comes through the town in May, to find the inhabitants dressed in green and armed for the May Play: a couple of Baillie's sons take up the cry 'a Lorebourne', their fathers repeat it: shots are fired and horses wounded: the Messenger and his men flee: church burials have been outlawed some years before, a family break open the church door with tree-trunks and bury a dead relative within, whereupon another family hurry home, grab a corpse, and bury it, and a third family dig up an uncle and are about to bury him when the Law finally turns up: Herbert Cunningham, Sheriff and Town Clerk, composing himself in his pew in church for the service when the Irvings break in, beat him, smash up his pew and cast it out in the aisle: he gets it repaired and the following week the process is repeated and he is threatened with death ...

It makes twenty-first-century Dumfries seem a sleepy wee town.

DID YOU KNOW THAT...?

A church was built in 1817 on the corner of Buccleuch Street and Castle Street. Dedicated to St Mary, the general public referred to is as 'the English Chapel'. It caused great controversy by introducing something no other church in the town had – an organ. The church was sold to the Wesleyan Methodists in 1862 and is now the Robert the Bruce pub.

2. Crime and Punishment

Conditions in eighteenth-century Dumfries jail were atrocious. A prisoner's clothes were so soaked by the water dripping from the roof they were rotting on his back while his leg irons had eaten through to the bone.

The jailors were often ex-prisoners who agreed to take on those hated jobs in exchange for their release from prison, which may go some way to explain their behaviour. A visitor to the jail complained he was arrested for no reason and his watch removed. In the 1720s the practice of exposing an executed murderer's hands on spikes still existed. When a murderer from Dumfries was executed in Edinburgh a baillie sent his hands to be exposed in Dumfries.

DID YOU KNOW THAT...?

In sixteenth-century Dumfries anyone caught stealing his neighbour's peat was branded on the cheek with the town clock key, heated in a fire made of the stolen peats.

The Rainbow Stairs.

The Burgh Tolbooth was built in 1481 and rebuilt in 1718 and the town council held its meetings there until 1832. Under the flight of steps known as the Rainbow Stairs was a small lock-up for people awaiting trial. It was in use until the Midsteeple was built in 1707. From the top of the stairs, proclamations were made, and thieves branded with the town clock key. When the council moved out in 1832, the building became the Rainbow Tavern. Burton's development led, unfortunately, to the demolition of this historical part of the town.

Beggars were given short shrift. If they did not have an official token proving they could not work they were branded and banished from the district; caught returning they risked being hanged. Those who committed the crimes of scandalmongering were punished with the scold's bridle – or branks – an iron frame that enclosed the head, with a bridle-bit projecting into the mouth pressing down on the tongue.

The burgh court dealt with crimes except those that involved a capital sentence or transportation. Of the seventy people in prison in 1790, twenty-three were debtors while seventeen were there for theft, four for housebreaking and five for desertion. Forgery, bastard children and petty crime made up the rest of the prison population while six were in prison for the crime of 'carrying off voters at the General Election'.

DID YOU KNOW THAT...?

Buyer and seller of one man's wife were brought to court and although they declared it had been a joke, they were fined £100 apiece and sentenced to spend an hour in the jougs, or juggs – iron collars on a chain fastened to a wall, often beside the parish church gateway. The views of the wife do not seem to have been recorded.

For capital offences, the majority of cases were for stealing livestock. Although most were acquitted, not all were so lucky. Two brothers were convicted of 'stouthrief' – using violence to steal twelve sheep. They were sentenced to hang. Another, Bauld Jok, who only stole five sheep, received a lighter sentence: 'to be drowned till he be deid in the watter of the Nith'.

From the late sixteenth century and at various intervals through until the mid- to late seventeenth century, witchcraft caused moral panic throughout the country. Dumfries was caught up in this hideous bit of history.

By the summer of 1658 Dumfries congregations were being asked to collect evidence against anyone suspected of witchcraft. Ten women were brought to trial in April 1659. The case against one, Helen Tait, was not proven but the others – Agnes Comenes, Janet McGlowane, Jean Tomson, Margaret Clerk, Janet McKendrig, Agnes Clerk, Janet Corsane, Helen Moorhead and Janet Callon – were found guilty. They were sentenced to be taken to the Whitesands, strangled at stakes and their bodies burned. In *History of Dumfries* McDowall paints a vivid picture of what the scene might have been like from 'the first

stage of torture, by which they are kept literally hanging between life and death; the second which shortly finishes by fire what the suffocating noose and smoke had only half accomplished ...' to the end, when there is 'nothing where the nine poor martyrs to superstition stood, save a morsel of blackened bones and a heap of bloody dust, while the grimy hangmen, like so many scavengers of death, are sweeping up ...'.

This was not the only time witches were executed in Dumfries. Two years earlier, two others had already been condemned to the same fate. In May 1657 the burgh treasurer's books has entries detailing the cost of the thirty-eight loads of peats to burn the two women: £3.12s. Other entries include the cost of a tar barrel, a herring barrel and the staves to which the women would have been tied.

Eight women were charged in 1671. Some were sent to Kirkcudbright for trial but Janet M'Muldritche and Elspeth Thomsone were found guilty and executed in the usual way.

The last Court of Justiciary trial for witchcraft in Scotland was in Dumfries in 1709. Elspeth Rule was said to have used 'threatening expressions' towards her enemies, who variously experienced the loss of cattle, death of friends and one went mad. She was found guilty but as we'd moved into a new century and more enlightened times, Elspeth was not condemned to death. Instead, she was banished from the town for life after having her cheek branded with a hot iron. Apparently smoke was seen issuing out of her mouth. Enlightened times indeed.

Dumfries has the distinction of being the last place in Scotland in which a woman was executed in public – and also the last place in which a man was publicly executed.

Mary Timney, a twenty-seven-year-old mother of four young children, was found guilty of murdering her neighbour Ann Hannah and was hanged on 29 April 1862.

The two women lived in a remote part of the region, near Carsphad close to what is now the Galloway Forest Park. Mary and her husband, a road mender who was often away from home for days at a time, rented the house from Ann Hannah. Ann was found, barely alive, in a pool of blood with a blood-stained butcher's knife and a piece of iron beside her. She died shortly after. Suspicion fell on Mary Timney, who had been known to argue with her neighbour. A bloodied wooden beetle or mallet was found in Timney's house, though she denied it was hers, and her clothes were blood spattered.

She was arrested and a date set for her trial, but even before she appeared in court the press had condemned her, describing her as a 'savage and implacable monster'. Her trial in Dumfries was presided over by Lord Deas. The jury unanimously found her guilty.

Lord Deas said, 'It only remains for me to pronounce upon you the last sentence of the law. The time of all of us in this world is short. With most of us it is uncertain – in your case your days are numbered.' Donning the black cap, he sentenced her to be 'hanged by the neck upon a gibbet till she be dead'.

The Kirkcudbright Advertiser reported, 'She said in the most heard rending tones "oh my weans, my Lord dinna dae that, oh dinna dae that, oh my weans, oh my weans, dinna dae that." The scene was harrowing in the extreme and affected many to tears.'

While awaiting execution, Mary confessed to the minister who visited her, telling him Ann Hannah had accused her of stealing wood. When she went to her house to 'give her a beating' she said Ann had kicked her, wounding her above her knee. As their fight continued, Mary seized the mallet and struck Ann, stunning her and then continued to beat her 'in the heat of passion' but had not intended to kill her.

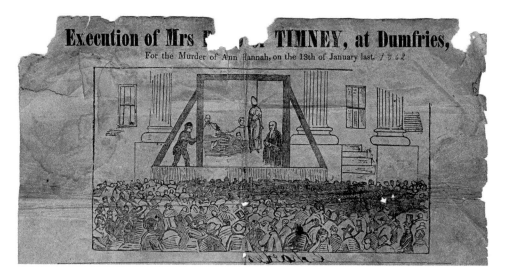

Execution of Mrs ??? TIMNEY, at Dumfries,
For the Murder of Ann Hannah, on the 13th of January last. 1862

Mary Timney broadsheet.

In the meantime the public were no longer eager to see Mary Timney hang. *The Kirkcudbrightshire Advertiser* wrote, 'The great majority of the public of Dumfries were horrified and indignant that this butchery should be permitted in their streets.' Three thousand people signed a petition asking that Mary Timney's sentence be commuted and William Ewart, the MP for Dumfries and an ardent campaigner for the abolition of the death penalty, was urged to take the case to Sir George Grey, Home Secretary. All to no avail.

The scaffold was erected on the corner of Irish Street and Buccleuch Street. The police and local militia were assisted by 200 special constables to control the crowd of around 3,000. Mary was led to the scaffold and then everything paused when a telegram was handed to the prison governor. Hoping it might be a reprieve, he was disgusted to find it was from a London newspaper, the *Evening Herald*, requesting 'the favour of a communication respecting the last moments of the unfortunate convict in time for the publication of the evening papers in the metropolis'.

Mary Timney's last words were 'Oh dear.' The crowds melted away, appalled at what they had witnessed. It was to be the last time the 'legalised strangling' of a woman would be carried out in public in Scotland.

In May 1868 a law was passed ensuring that executions be carried out inside prisons, not in public. The change in law came too late for Robert Smith, who was publicly executed in the town on 12 May. He was a young farm labourer from Eaglesfield, not far from Dumfries, and was found guilty of raping, murdering and robbing an eleven-year-old girl called Thomasina Scott in a wood between Annan and Cummertrees. Aware that a witness, a Mrs Creighton, had seen him go into the wood with the girl, he returned to her cottage and attacked her, stabbing her several times in the neck before running off when three men, hearing her screams, came to help her.

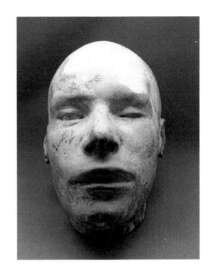

Right: Robert Smith death mask.

Below: Once the King's Arms where William Hare stayed.

William Hare, of the infamous serial killers Burke and Hare, had a fleeting interlude in Dumfries. Having been released by the prison authorities in Edinburgh where he had testified against his accomplice William Burke, who was hanged for the murders, Hare stayed overnight in Dumfries when en route to his native Ireland. An 8,000-strong mob gathered outside the Kings's Arms Hotel, some of whom burst in and would surely have torn him limb from limb had the police not cleared the room.

Burke and Hare had made a living from selling fresh cadavers to the anatomists in Edinburgh. Bodies were in short supply following the Judgement of Death Act of 1823, which reduced the number of crimes punishable by death. This led to the rise of grave robbers, or resurrectionists, who sold disinterred cadavers to the anatomists.

Burke and Hare skipped the dirty business of digging up fresh bodies by going straight to murdering people, thus ensuring the freshest possible corpse and a larger payment – up to £10 per body.

Between December 1827 and 31 October 1828 they murdered at least sixteen people, selling the bodies to anatomy lecturer Professor Robert Knox. They were caught when Burke's lodgers discovered the body of the latest victim, Marjory Campbell Docherty, hidden under a bed. Burke's mistress, Helen McDougall, tried to bribe the couple to remain silent but they went to the police. By the time the police arrived the body had disappeared, but Burke and Hare were arrested and when Hare turned King's evidence, Burke was found guilty and hanged on 28 January 1829.

In Dumfries, the town's magistrates decided Hare should be taken to the prison for safety. William McDowall gives a colourful account of the terrifying coach ride through the mob in his *History of Dumfries*: 'The mob becomes denser and more desperate; and the vehicle, wedged in all round, rocks with the heaving multitude as if it would capsize.' Hare, cowering inside, must have feared for his life. Did he, facing the possibility of his own death, feel any remorse for the lives he had taken?

When the crowds eventually dispersed in the night, Hare was taken from the prison and, instead of travelling to Portpatrick and Ireland, was 'conveyed to the English road by a sheriff's officer and two militiamen'.

3. Health

As the population of the town grew, cramped housing, bad sanitation and a lack of clean water led to several outbreaks of plague. The Auchinleck Chronicle, so called because the manuscript was once owned by the Boswell family at Auchinleck House in Ayrshire, records that in 1439, 'the pestilence came in Scotland and began at Dumfries and it was called the Pestilence bot Remeid (without remedy) for of those that took it, none ever recovered but they died within 24 hours'.

In 1598, all of Scotland suffered from devastating famine and Dumfries was not spared by either the famine or the plague, which followed it in 1599. Kirkcudbright Town Council banned anyone from going to Dumfries, or from even speaking to anyone from the east side of the River Nith. The loss of trade resulted in even further hardships for the townspeople.

Both famine and plague returned in 1623. Anyone suspected of being infected – regardless of their social position – was banished to Scabbit Isle and the Black Loch, the quarantine areas outside the town beside the Lockerbie Road. It is said mass burials of plague victims took place at Deadman's Hirst, and Bane Loaning is reputed to be where suicides were buried.

Fast forward two centuries and it was cholera which struck at the town. In March 1832, in an attempt to ward off the epidemic moving closer, the Board of Health was constituted and ordered the homes of poor people to be cleaned with hot lime, but nothing was done to improve the town's sanitation or water supply. On 15 September, an elderly widow living on English Street was taken ill and died the next day. Her neighbour from the house opposite was next to go and for a week there was around one death a day. Then the number of cases and the mortality figures began to rise.

The Board of Health decided against admitting patients to the Infirmary. Instead, an old granary on English Street was converted into a makeshift, overcrowded hospital. The High School was turned into a refuge for widows and orphans escaping from their homes, a soup kitchen was opened and tar was burned in the street in an attempt to disinfect affected areas.

Eventually the epidemic ran its course, leaving a death toll of 550 people, with 350 of the victims being buried together in what is known as the Cholera Mound in St Michael's churchyard.

In 1848 another outbreak returned to the town, claiming a further 450 lives. At the Crichton Royal Institution, which opened in 1839, not one person contracted the disease despite cases very close by. The medical superintendent, Dr Browne, thought at first it was the strict quarantine he had put in place. However, he came to understand it was down to the water filtering system that he had installed. In Dumfries itself it was 1851 when the town achieved a pure water supply, piped from Lochrutton Loch.

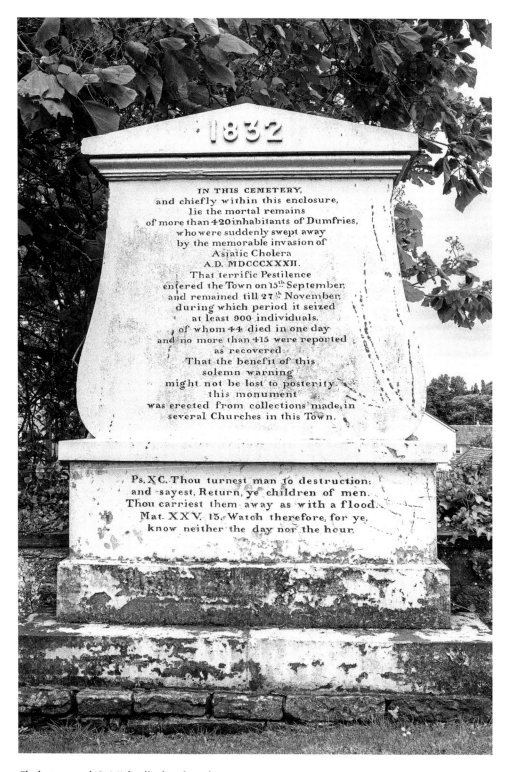

IN THIS CEMETERY,
and chiefly within this enclosure,
lie the mortal remains
of more than 420 inhabitants of Dumfries,
who were suddenly swept away
by the memorable invasion of
Asiatic Cholera
A.D. MDCCCXXXII.
That terrific Pestilence
entered the Town on 15th September,
and remained till 27th November,
during which period it seized
at least 900 individuals,
of whom 44 died in one day
and no more than 415 were reported
as recovered:
That the benefit of this
solemn warning
might not be lost to posterity,
this monument
was erected from collections made in
several Churches in this Town.

Ps. XC. Thou turnest man to destruction:
and sayest, Return, ye children of men.
Thou carriest them away as with a flood.
Mat. XXV. 13. Watch therefore, for ye,
know neither the day nor the hour.

Cholera mound, St Michael's churchyard.

As mentioned above, the Crichton Institution (the Royal epithet came around a year after opening) was opened in 1839. Its benefactress, Elizabeth Crichton, initially wanted to use the legacy her late husband left to found a university in Dumfries. When prevented by the existing Scottish universities from doing so, she decided instead to build a lunatic asylum. This, too, met with strong opposition from the public and in the local press, not least for the 'disproportionate magnitude' of the plans, but she was not to be thwarted a second time.

In June 1839 *The Shipping and Mercantile Gazette* ran an advertisement informing its readers The Crichton Institution for Lunatics, Dumfries, was open and receiving patients. The advert made much of the asylum's situation and fine views of Criffel and the Solway Firth, its extensive grounds and gardens and of how it would be run on the lines of 'justice, benevolence, and occupation'. Readers were assured the attendants, whose duties were to 'soothe, encourage, amuse, or employ', had been chosen with great care.

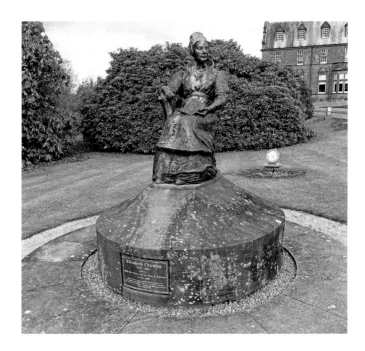

Right: Elizabeth Crichton, founder of the Crichton Royal Institution.

Below: Crichton Hall.

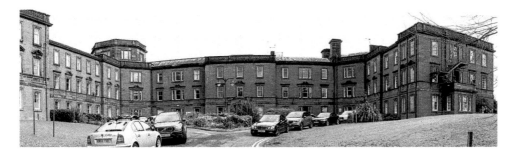

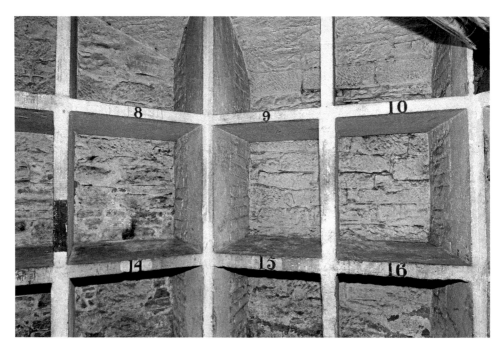

Wine cellar for wealthy patients.

The description of the accommodation read like an advert for a superior hotel. For patients from the higher ranks of society the accommodation included parlour and bedroom – 'elegantly furnished' – and their meals included wines and seasonal game. Wine cellars in which the well-off patients could keep their claret were built into the basement. At the lower end of the social scale each pauper was to be given a separate bedroom and share a public room with ten others. Soup was provided every day and meat three times a week with the additional luxury of tea for the women and tobacco and beer for the 'industrious males'. This would be luxury for those classed as paupers.

Dr Browne advocated what he called moral treatment in which the patient was treated as an individual. 'Its secret,' he declared, 'lies in two words – kindness and occupation.' Keeping the patient occupied to prevent 'morbid thoughts' was key to the new treatment; for the paupers there was work in the laundry, or as domestic servants, farm labourers or gardeners. Privileged patients could take regular carriage drives and there was lawn tennis, putting, bowling and picnics. Indoor pursuits included reading, drawing and painting, embroidery, concerts and theatricals.

The first theatrical performance ever to be given in a mental hospital took place in the Crichton in 1843. Raising the Wind, a farce by James Kenney, was produced entirely by the patients, who also acted in it. Such proceedings, according to Dr Browne's son, Sir James Crichton-Brown, himself an eminent psychiatrist, 'were looked at askance by Calvinistic circles in Dumfries. But the performance was under the immediate patronage of Mrs Crichton of Friars' Carse, and the Minister of St Michael's Church ... Dr Wallace, who was on the Board of Directors at the time; so that settled the matter'.

DID YOU KNOW THAT...?

The first nursing lectures in the country, probably in the world, were given in Dumfries at the Crichton Royal Institution. Wanting to improve the knowledge of the attendants employed there, Dr Browne introduced a series of nursing lectures – six years before Florence Nightingale started her training school in London.

In another first, patients contributed to and produced their own magazine. The *New Moon Magazine* was first published in 1844. Widely circulated, this monthly magazine was so profitable that by 1846 a printing press was purchased from the profits.

In 1849 a second building was added to accommodate pauper lunatics from the surrounding areas, called the Southern Counties Asylum. The two institutions merged in 1884 becoming the First and Second Houses of the Crichton Royal Institution. Industrial therapy was employed with patients working on the hospital farm, in the laundry and gardens, and the hospital had its own bakery, printworks, power station, water supply and a fire service, making it practically self-sufficient.

Among the patients who found asylum at the Crichton were Arthur Conan Doyle's father, Eva Margaret (Evey), the daughter of artist Helen Allingham and her poet husband William, and Angus Mackay, Queen Victoria's official piper. During an escape attempt in 1859 he drowned in the River Nith. A monument to him has been erected on the riverbank. Rumours abound of other well-known figures being patients in more recent times, but records are not available for public perusal until seventy-five years after the death of a patient.

Succeeding medical superintendents Dr Rutherford and Dr Easterbrook added more patient and staff accommodation – the Crichton Memorial Church and Easterbrook Hall. At one point, the Crichton extended to some 1,000 acres in area. It gained an international reputation and throughout its history was in the forefront of a psychiatric revolution. Dr Willi Mayer-Gross, a refugee from Heidelberg University in Germany, became director of clinical research from 1939 to 1954, at a time when new therapies were being tried and tested – insulin coma therapy, electro-convulsive therapy and pre-frontal leucotomy – and the introduction of drug therapies, which were to change the face of psychiatric treatment.

The hospital became part of the NHS in July 1948 and from the 1970s to 1980s was gradually scaled down with provision for patients being made elsewhere. The last patients left the Crichton site at the end of 2011.

At least Elizabeth Crichton's vision came true as the Crichton Campus is now home to University of Glasgow, University of West of Scotland, Open University, Dumfries and Galloway College, Crichton Carbon Centre and Scotland's Rural College.

Moorheads' Hospital, endowed by two brothers, James and William, both merchants, was built on St Michael's Street, directly opposite St Michael's Church, in 1735.

Left: Memorial of Angus McKay, Queen Victoria's piper.

Below: Text on McKay memorial.

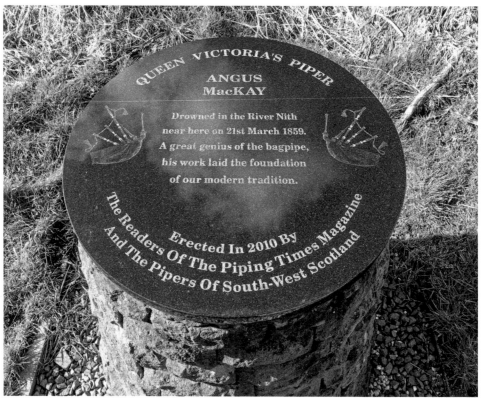

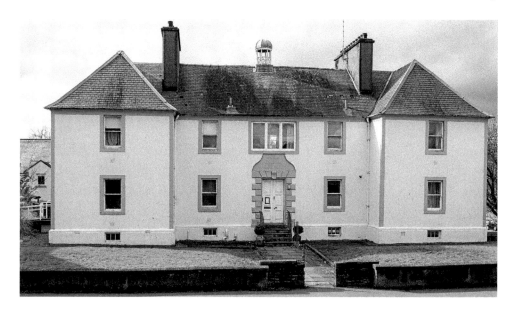

Above: Moorheads'
Hospital.

Right: Wording above
the door.

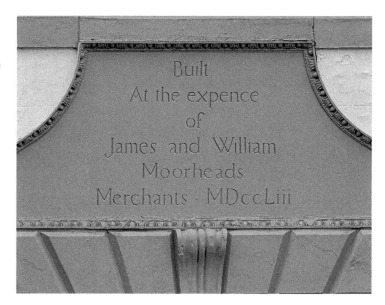

Built
At the expence
of
James and William
Moorheads
Merchants · MDccLiii

It was designed, says McDowall in *History of Dumfries*, 'as a domestic retreat for decayed burgesses and destitute orphans, natives of the town'. Residents were provided with clothing, food and medical attendance if needed. Those who could work were encouraged to do so. As the hospital was built at a time when such charitable institutions were rare, the 'decayed burgesses' must have been very grateful.

The first Infirmary was in use from 1777 in rented accommodation. It was situated near Robert Burns House in the Mill Hole. According to Gordon Irving's *Dumfries &*

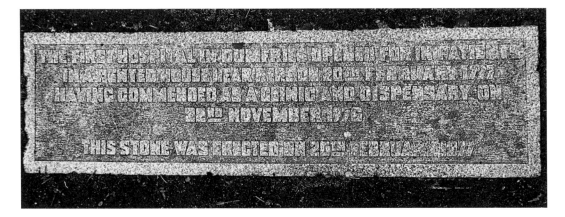

Plaque indicating site of first infirmary.

Galloway Royal Infirmary – the first two hundred years it had 'two wards of four beds each, apothecary's (or house-surgeon's) shop, and residential quarters for apothecary, a matron, a nurse and a domestic servant'.

The foundation stone for the first purpose-built hospital was laid in July 1777 and opened in 1778. As well as wards for general patients, it had four cells for lunatics. The gardener was appointed to be their attendant. One of his roles was to bring back escapees. Various additions were added over the years, including, in 1790, a new lunatic wing, in use until the Crichton opened in 1839.

The hospital was granted a royal charter on 7 April 1807 by George III and became the Dumfries and Galloway Royal Infirmary. It was in this hospital that the first surgery using general anaesthetic – sulphuric ether – was carried out in Europe, on 19 December 1846, two days before Dr Liston carried out an amputation in London.

News of the first successful use of anaesthesia in America arrived in Liverpool on 16 December when the Royal Mail steamship *Arcadia* docked. Letters to a doctor in London as well as a copy of the *Boston Daily Advertiser* containing information about the American surgery arrived on the ship – so too did a young doctor, William Fraser, who was the ship's surgeon. He had seen the operation being carried out and made his way to Dumfries, partly to visit his widowed mother but also to relay the news to James McLauchlin (who died of cholera in the 1848 outbreak), senior surgeon at the Royal Infirmary, and his junior colleague William Scott. The doctors improvised some apparatus and William Scott administered ether to a patient with a fractured limb and carried out the surgical procedure.

The accolades for the first use of ether in surgical operations went to Mr Liston of London. An article in the *Lancet* prompted William Scott to write to the publication with a correction. In corroboration of his assertion he was the first, he mentions the late Professor Simpson who, in lectures at the Royal College of Surgeons in Edinburgh, publicly stated Dr Scott was the first.

A gift of £5,000 was made by Mrs Laurie of Maxwelton to be used in building a new hospital, on condition a ward be named the Laurie Ward in memory of her late husband.

Nithbank, third infirmary.

DID YOU KNOW THAT...?

Penicillin was so scarce at the outset of the NHS that it was recovered from the patients' urine to be used again. An acutely ill boy in Dumfries was saved by injections of the new drug and was supplied with ten large jars to be returned to Glasgow for removal of the drug.

A grand procession of dignitaries marched from the Academy to the new hospital site, almost opposite the existing one, on 16 September 1869. The hospital, which had 100 beds, cost £16,000. It served the town and region until 1975 when the Queen opened the next Dumfries and Galloway Royal Infirmary. It was built on what was a nine-hole golf course belonging to the Crichton Royal Hospital and the joint Crichton and Dumfries and Galloway Royal Infirmary Board moved the golf course across the road. With 424 beds, it cost over £5 million.

Its successor, just outside the town, opened in December 2017, just over forty years later. Hospitals don't seem to be built to last like they used to.

Only the wording on a gatepost remains of the Dumfries and Maxwelltown Combination Fever Hospital which stood on Greenbrae Loaning. It was opened in 1910 and closed in the 1960s. It served Dumfries, Maxwelltown and Lower Nithsdale. Infectious diseases hospitals were run by the local authority but came under NHS management on 5 July 1948. Most sizeable areas of population had their own infectious diseases hospital because of transportation, which originally was by horse-drawn ambulance.

DID YOU KNOW THAT…?

James Robertson Justice, who played the irascible surgeon Sir Lancelot Spratt in the Doctor films, prepared well for his role. In the 1950s consultant surgeon John Neilson at Dumfries and Galloway Royal Infirmary received a call from a friend to say he had an actor as a guest who would like to talk to him about his work. Apparently he sat in on operating sessions at the hospital watching the surgeon and his team at work.

Like all infectious diseases hospitals it had an administrative block and separate units for scarlet fever and diphtheria, outbreaks of which led to peaks and troughs and stemmed from overcrowding in the early twentieth century. Other infectious diseases were treated there including erysipelas, meningitis and, in the late 1940s and early 1950s, poliomyelitis. Matron and staff lived in and a local GP would provide medical care.

The usual length of stay for a patient with scarlet fever was forty-two days. Parents were not allowed to come into contact with their children and were restricted to looking in at a window. Inoculation against infectious diseases and modern drugs and antibiotics led to the closure of this and similar hospitals.

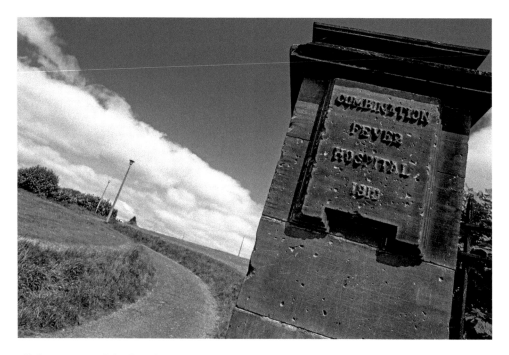

All that remains of the fever hospital.

4. Industrial Dumfries

For a time Dumfries enjoyed a thriving shipping trade. The port included Dumfries, Kingholm Quay, Kelton, Glencaple and Carsethorn. By the eighteenth century the town's links with the North American colonies and the tobacco trade led to it being nicknamed 'The Scottish Liverpool'.

The largest import item was coal from Cumberland and lime was imported for use as fertiliser. Textiles, wine and brandy came from France and Spain, providing a lucrative trade for the smugglers on the Solway. Dumfries was exporting grain, potatoes, sheep, cattle and pigs to dozens of destinations in the UK, throughout Europe and America.

In the 1840s trade was impressive, with 25,000 tons coming into the port and the *Countess of Nithsdale* steamboat linking with Liverpool. The Nith, however, became a dangerous river for even small boats to navigate and commissioners were appointed to oversee plans for improvements drawn up by civil engineer James Hollingsworth. Unfortunately, the costs of improvements outweighed the benefits and the arrival of the railways brought about an irreversible decline.

Although Dumfries has never been a major industrial centre, various industries managed to secure a foothold, creating prosperity for the town.

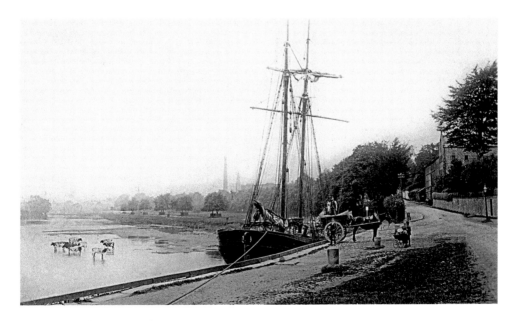

Dock Foot in the nineteenth century.

DID YOU KNOW THAT...?

Dumfries has many fine sandstone buildings, erected during the prosperous years of the nineteenth century. The sandstone is from the nearby Locharbriggs Quarry, which is Scotland's oldest working quarry and one of the few sandstone quarries still being actively worked in Scotland today. Excavation began in 1740 and the pink to red sandstone has been used in high-profile buildings such as the Glasgow Museum and Art Gallery and The King's Theatre in Edinburgh as well as in local buildings.

Looking at the derelict Rosefield Mills today, on the west bank of the Nith, it's sad to see what years of neglect has done to such an iconic building. It was once one of the biggest tweed mills in Scotland, employing 700 workers. The partnership of Samuel Charteries and Robert Spence built it in 1886 on land they bought next to the existing Troqueer Mills, owned by Walter Scott & Sons.

In the 1870s and 1880s, Dumfries was one of the largest tweed producers in the world with four mills and almost 2,000 workers. The finished product was exported

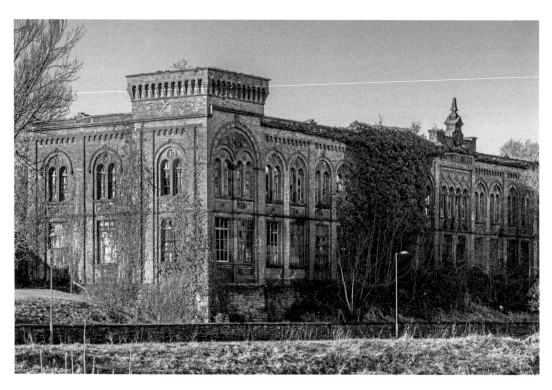

Rosefield Mills.

to the United States, Europe, Russia and Australia. Queen Victoria, with her love of all things Scottish, helped to make tweed fashionable around the world. It was at this time that the suspension bridge was built, opening on New Year's Eve 1875. This greatly suited the millworkers as they no longer had to walk the length of the Whitesands to cross the river.

The First World War saw the beginning of the end of the tweed mills' success. During the war they manufactured khaki and French army blue cloth, but after the war ended they never recovered their old markets. Troqueer Mill closed after a fire in 1923 and although Rosefield carried on for several more years, they could not survive the Depression.

Dumfries Historic Buildings Trust has an agreement to purchase the Rosefield Mills and has been working to raise funds to complete the purchase and to restore the building for the benefit of the wider community.

The manufacture of hosiery became an important part of the town's economy in the nineteenth century, although it began earlier as a cottage industry. The introduction of the stocking frame in the late eighteenth century allowed it to flourish.

In 1810 Robert Scott went into partnership with William Dinwiddie to further develop the manufacture of hosiery and within a couple of decades, as others followed their example, over 300 people were employed in the business. By 1869, further expansion of the firms – R. Scott & Sons, Milligan & Co., James Dinwiddie & Co. in Dumfries and William Halliday and Robert McGeorge across the Nith in Maxwelltown – led to employment for over 500 workers.

Amalgamations and changes in partnerships inevitably occurred leaving two firms, James McGeorge and J. A. Robertson, as leaders in the field. McGeorge's was the largest, specialising, from 1855, in producing gloves on knitting machines that they designed themselves. They also made stockings and ties. The firm continued to expand – into the weaving shed of the St Michael's Mills and into part of the Nithsdale Mills where over 700 workers were employed.

J. A. Robertson & Sons, which came to be known as Drumohr Knitwear, was founded in 1773 by James Paterson. In 1805 he began making knitting machines, which he hired out. The firm took on premises at Saughtrees, between the Annan and Lockerbie roads, in 1870. It made stockings in jacquard colour patterns, sold in Harrods. King George V wore them and Queen Mary used to return hers via Harrods to the Dumfries factory for re-footing.

After the Second World War, when the factory was requisitioned, recovery was slow, but the post-war workforce of twenty increased to match the 200 of pre-war times. Smaller factories were established in other towns. Despite another royal connection when Princess Di was photographed wearing a pullover made by Robertson's shortly after her engagement to Prince Charles, the company, and that of J. & D. McGeorge, closed in the 1990s.

In July 1913, Arrol-Johnston moved into a purpose-built factory designed on similar lines to Ford's Highland Park plant in Michigan designed by Albert Kahn – the first factory of ferro-concrete construction built in Britain.

The company started in the 1890s when Glasgow-based locomotion engineer George Johnston designed a car known as a dog-cart. Civil engineer Sir William Arrol, of the

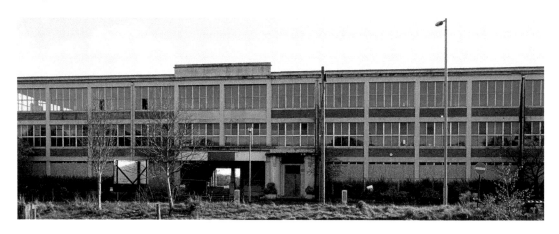

Arrol-Johnston today.

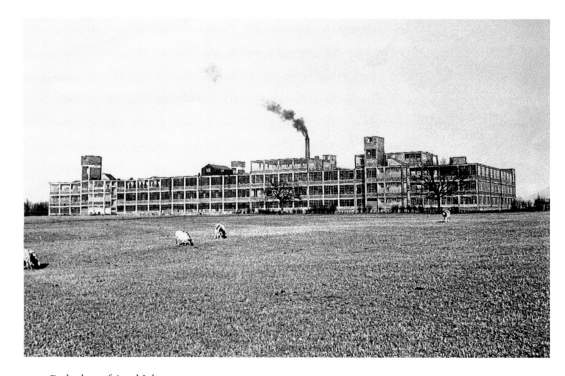

Early days of Arrol-Johnston.

iconic Forth Bridge fame, invested in the project, which was initially called the Mo-Car Syndicate. The cars were produced in a small work in the east end of Glasgow until it was destroyed by a fire. Archibald and Peter Coats of the Coats Thread Co., who were financial backers of the syndicate, offered space in one of their disused thread mills.

In 1908 T. C. Pullinger, or TC as he was known, joined Arrol-Johnston as managing director. He had vast experience in the rapidly developing car industry. He had won a gold

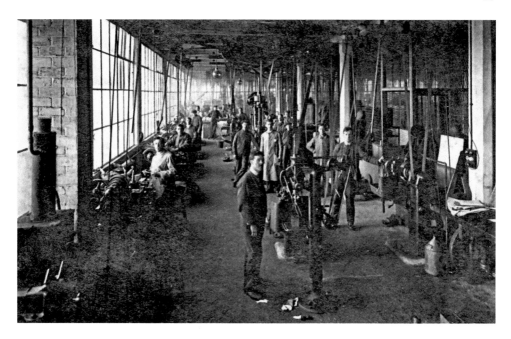

Interior of the car factory.

medal at the 1900 Paris International Exhibition for his design of an internal combustion engine. He had worked for Darraq and in England for Sunbeam and Humber.

TC brought in a new, very successful 15.9-hp model. Other models followed; the company was making a profit and ready for expansion. He fixed on the site at Heathhall. It was ideal as it had land available for further expansion and there was also a rail link to markets in England and a local workforce in Dumfries.

During the First World War the company stopped car production and switched to aero engines, including the Beardmore Halford Pullinger engine.

Unfortunately, the car factory at Heathhall did not enjoy post-war success. Sales of the Victory model were hurt after bad publicity when the Prince of Wales abandoned a tour of the West Country in it. Sales continued to decline and in 1927 the company amalgamated with Aster of Wembley becoming Arrol-Aster. A year later it won the contract to rebuild the body of Sir Malcolm Campbell's *Bluebird* in Dumfries, but it was not enough and the company went into liquidation in 1929.

DID YOU KNOW THAT...?

Between 1905 and 1908 around 125 Drummond cars were produced by McKinnel's Foundry, renamed the North British Motor Manufacturing Co. Problems with the gears led to the demise of that short-lived venture.

Dumfries was once the world headquarters of the famous Hunter Green Wellie. The company, which was started in Edinburgh in 1856 by an American called Henry Lee Norris, was originally called The North British Rubber Co. During the First World War, the War Office asked the company to make a sturdy boot suitable for use in flooded trenches and they duly produced 1,185,036 pairs.

They were asked to supply Wellington boots again in the Second World War as well as thigh boots, groundsheets, lifebelts and gas masks. By the end of the war, the company had expanded so much it required bigger premises. It moved to Dumfries, into what had been the Arrol-Johnston factory.

In the winter of 1955 the original Green Wellington was made – Hunter's most famous welly. The royal family rather took to the green wellies and in 1977 the Duke of Edinburgh awarded Hunter a Royal Warrant. The Queen took a bit longer to decide and it was 1986 before she awarded her royal warrant.

By then, North British Rubber had been bought by Uniroyal Limited, the car tyre company, and in 1986 it was sold to Gates Rubber Co. Further sales and buyouts occurred over the next few years. To celebrate the fiftieth anniversary of the green wellie Hunter decided to release a range of seven differently coloured boots for adults and children.

Unfortunately, despite increased sales, the company faced problems. The factory was old, expensive and inefficient and Hunter decided to use other supply sources in Europe and the Far East. By 2008 the company had relocated its headquarters to Edinburgh. Dumfries lost its position as the home of the famous green wellie.

This chapter ends with a success story. Back in 1939 the Ministry of Supply was looking for a location for a factory to manufacture acids and nitrocotton for explosives. It had

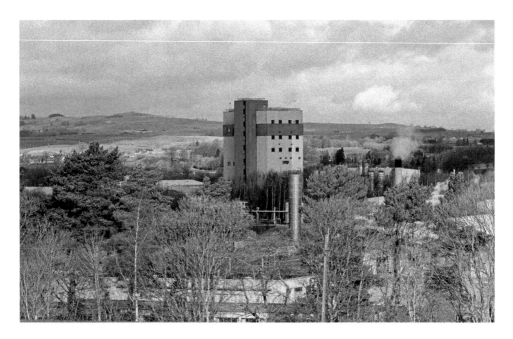

ICI, now DuPont Teijin.

to be reasonably safe from bombing but within reach of ICI's factory and laboratory at Ardeer in Ayrshire. When Drungans at Cargenbridge was chosen it was a bit of a shock to farmer James Nodwell to be told his land was to be taken over by the government.

ICI began building the plant, which included over forty buildings for production, storage, offices, fire station and canteen plus a mile of roads and almost 2,000 yards of railway line. It was ready for production to begin in early 1941. It employed 1,350 staff, almost half of whom were women. After the war ICI's Nobel Division bought the plant from the ministry in 1949 and began work on the production of a textile, designed as a wool substitute, made from peanuts. It was not a success. The price of groundnut meal went up, there was a depression in the textile trade and ICI elsewhere were producing new man-made fabrics Nylon and Terylene, which were much more successful.

The big breakthrough came with a film called Melinex. It was soon used in just about everything: as a replacement for tracing paper, for X-rays and photography, book and magazine covers, wine cartons and greenhouse glazing, and as a thermal shield for space satellites. In 1998 it was taken over by DuPont Teijin, and is still going. It received a £1,000,000 funding boost in 2017.

DID YOU KNOW THAT...?

Three Dumfries banks issued their own banknotes. The Dumfries Bank (1766–72) issued £1 and £20 notes. The Dumfries Commercial Bank (1804–08) issued notes in the denomination of one guinea (£1.05p) and £5, and the Southern Bank of Scotland (1838–40) issued £1 and £20 notes.

5. Wartime Dumfries

When Joseph Brown died in March 1927 he was the last survivor in the Dumfries district of not only the Crimea War but also the Indian Mutiny. He enlisted in the Argyll and Sutherland Highlanders at the age of eighteen and in 1855 was sent out to join a battalion in the Crimea, where he served for eleven months until the end of hostilities.

Joseph returned home in June 1856 and the following year was being sent with a 1,200-strong battalion to join the China expedition. News of the Indian Mutiny (or the First War of Independence) reached them at the Cape of Good Hope and they changed course for India. Under the command of Sir Colin Campbell, the British marched to Lucknow where the Residency had been under siege for several months. Joseph Brown, in the advance guard,

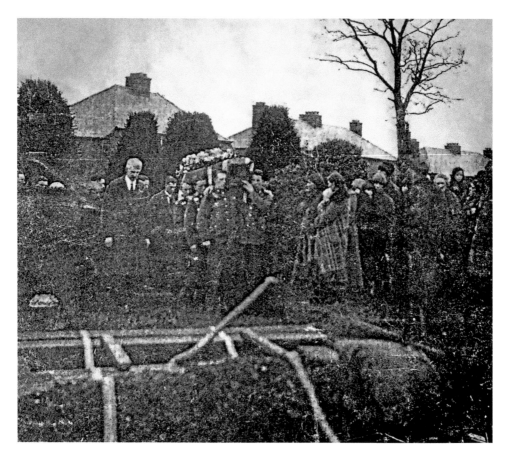

Funeral of Joseph Brown.

said, 'We were the saviours of the saviours as the first relief expedition had themselves been closed in.' He remembered the fighting lasted seven days and seven nights.

They then marched to Cawnpore (now Kanpur). He described the engagement at Cawnpore, saying, 'The mutineers had gathered in strength, and they formed a square to receive the charge of the cavalry. The 9th Lancers were in front, with the guns of the Royal Horse Artillery behind, The Lancers charged, but as they approached they wheeled to right and left, and the guns which had been placed behind opened fire and made streets in the close columns.'

Joseph Brown's adventures were not yet over. While engaged in digging a passage through a wall, he was buried when it collapsed, pushed over by some elephants on the other side. He emerged unscathed. In 1858 however, he had sunstroke, from which he nearly died. When he returned to Dumfries he served in the Dumfries Militia. He died at the age of ninety-one and is buried in St Michael's churchyard.

Several memorials to the fallen of both the First and Second World Wars can be found in Dumfries. Outside St John's Church on Newall Terrace a soldier of the King's Own Scottish Borderers in service dress stands on a granite monument. There are 467 names of those killed in the First World War and 336 from the Second World War. Those who died in other conflicts are also commemorated including one who died in the Korean War (1950–53), one during the Malayan Emergency (1948–60), one in Vietnam (1955–75) and two who died in Afghanistan (2001–14).

The Maxwelltown and Troqueer memorial on the New Abbey Road commemorates the 219 men who died in the First World War including Private James Mackenzie,

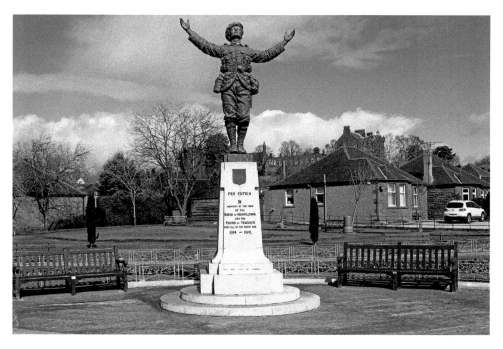

Maxwelltown war memorial.

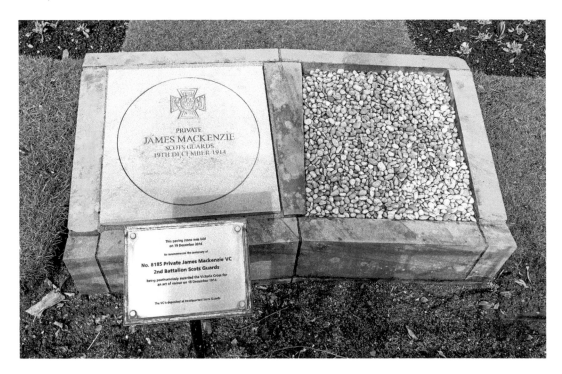

Memorial to James Mackenzie VC.

who was awarded the Victoria Cross for conspicuous bravery. He went to France with the 2nd Battalion of the Scots Guards in October 1914. He was killed only two months later when the battalion launched a night attack on the German trenches at Rouges Bancs. His citation in *The London Gazette* of 6 February 1915 reads,

> For conspicuous bravery at Rouges Bancs on the 19th Dec, in rescuing a severely wounded man from in front of the German trenches, under a very heavy fire and after a stretcher-bearer party had been compelled to abandon the attempt. Private Mackenzie was subsequently killed on that day whilst in the performance of a similar act of gallant conduct.

He was the first of two Dumfries men to be awarded the Victoria Cross (there were five recipients of the award in Dumfries and Galloway). As well as being remembered on the Maxwelltown war memorial and by a plaque in Troqueer Parish Church, Private Mackenzie is commemorated on the Ploegsteert Memorial to the Missing near Ypres. In 2014, 100 years after his death, a commemorative paving stone was unveiled at the Maxwelltown War Memorial.

The second Dumfries man to receive the VC was Lieutenant James Edward Tait, born in Maxwelltown. In November 1915 he enlisted in the Canadian Expeditionary Force and was awarded the Military Cross in April 1917 for his conduct the day the Canadian Corps attacked and captured Vimy Ridge in France.

The Victoria Cross was awarded posthumously for his actions during the first four days of the Battle of Amiens, in August 1918. *The London Gazette* citation says,

> For most conspicuous bravery and initiative in attack. The advance having been checked by intense machine-gun fire, Lt. Tait rallied his company and led it forward with consummate skill and dash under a hail of bullets. A concealed machine gun, however, continued to cause many casualties. Taking a rifle and bayonet, Lt. Tait dashed forward alone and killed the enemy gunner. Inspired by his example his men rushed the position, capturing twelve machine guns and twenty prisoners ... when the enemy counter-attacked our positions under intense artillery bombardment, this gallant officer displayed outstanding courage and leadership, and, though mortally wounded by a shell, continued to aid and direct his men until his death.

Tait is buried at Fouquescourt British Cemetery, has a memorial plaque in Troqueer Parish Church and his medals are held in the Glenbow Museum, Calgary, Canada.

Three men – Private Thomas Donnelly, Private Augustine Hullin (both from the Royal Scots Fusiliers) and Able Seaman Andrew Carnochan of the Royal Navy – are buried in Dumfries (Holy Cross) Roman Catholic Cemetery. As their individual burial places are not known, the Commonwealth War Graves Commission erected a new war memorial to them in 2016.

On the sandstone war memorial in Kingholm Quay are the names of eight casualties of the First World War – four from one family. As there were only eighteen houses in Kingholm Quay then, the community lost a high percentage of its young men and Annie McFarlane lost all but one of the men in her family. Of her four sons, three – James, Martin and John – joined the King's Own Scottish Borderers and George enlisted with the Argyll and Sutherland Highlanders. James MacFarlane was killed in May 1915, Martin died at the

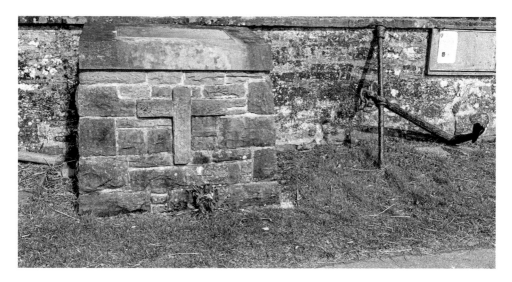

New Kingholm Quay memorial.

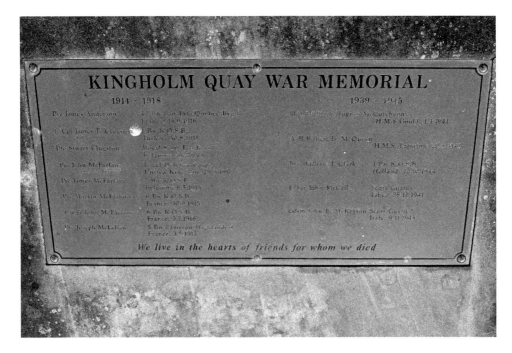

Highlighted text on the memorial.

end of September that year and John in July 1916. Her husband, Private John McFarlane, who had previously served in the army for twenty-one years and was too old for active service, rejoined. He was killed while on railway guard duty, aged fifty-one.

George, the fourth son, was taken prisoner at the first battle of Mons and was held as a prisoner of war in Germany. He returned home on the second day of 1919. McFarlane Avenue in a Kingholm Quay housing estate is named in commemoration of the family.

A tablet was wall mounted at the public entrance to the caller office by the staff of the general post office at No. 7 Great King Street as a tribute to the memory of their brave comrades who lost their lives in the two world wars. It records twelve names – eight from the First World War and four from the Second World War.

During the First World War, the Arrol-Johnston car factory switched from producing cars to aircraft engines and, later, aircraft. There was a landing strip at Tinwald Downs Farm for planes flying in to collect aero parts. In 1938, the Air Ministry built an airfield and aircraft storage facilities. It was used from June 1940 by the 18 Maintenance Unit, which received new aircraft for testing and modifications ready for war. It is estimated that 18MU prepared and dispatched nearly 5,000 aircraft. A Bombing and Gunnery School was established and, later, training for navigators.

On 25 March 1943, a German aircraft shot up the airfield beacon before crashing. The pilot, Oberleutnant Martin Piscke, was buried in Troqueer Cemetery with full military honours. Several training accidents occurred in which a number of lives were lost. The occupants of two Dumfries Ansons were killed when the aircraft collided over Maryport

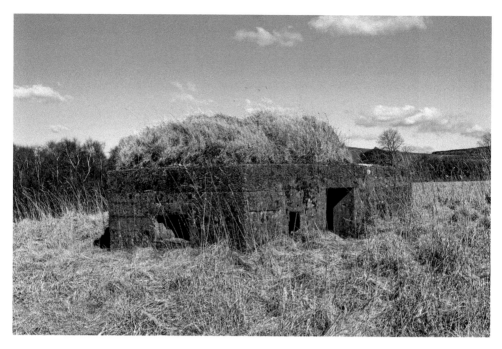

Pillbox near Heathhall, visible from the road.

in Cumbria in May 1943. On the night of 9 August 1943 three Ansons crashed into the hills in the Lake District. Also in August, though not a training incident, a Wellington bomber with engine problems crashed short of the runway.

DID YOU KNOW THAT…?

Along with Durham and Derby, Dumfries was one of the UK towns worst affected by the First World War in terms of soldier losses. According to research by the genealogy website Ancestry, the town had a pre-war population of 30,258. A total of 1,448 men were lost during the war. It was a local loss significantly higher than in other places.

Thirty years on some aviation enthusiasts heard rumours that the Wellington's engines were still buried on the site of the crash. Eventually, two Bristol Hercules engines, one of which still had its wooden propeller, were raised. Other artefacts were found and realising there would be interest in these finds, the Dumfries and Galloway Aviation Group was formed in 1976 and used a disused pilot's flight hut in which to display the collection. The group acquired its first complete airframes from the Royal Aircraft Establishment

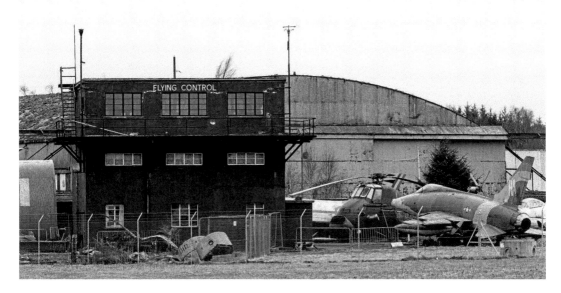

RAF Dumfries control tower, now the Aviation Museum.

at West Freugh near Stranraer and in 1977 the Dumfries and Galloway Aviation Museum opened to the public. It moved to its current larger site in 1979, which includes the old, three-storey control tower of RAF Dumfries, now a listed building. As well as a huge collection of aircraft, the museum offers visitors displays of aviation memorabilia and a recreation of a wartime control room.

It is no secret that Dumfries became the headquarters for the Norwegian army in exile during the Second World War, but such a fascinating piece of the town's history is worth retelling briefly.

When Germany invaded Norway, despite its declaration of neutrality, the Norwegian merchant fleet headed for Allied ports with 3,000 men arriving in Britain. They were sent to Hamilton, near Glasgow. The officer in charge, Lt-Col Carl Stenersen, instructed a group of over 300 men to travel to Dumfries. They arrived at Dumfries station on 28 May 1940, followed by hundreds more, some of whom had made the risky North Sea crossing in small boats.

Shortly afterwards, when the government of Norway declared war on Germany those Norwegians in Dumfries enlisted as soldiers. At one time there were 1,000 men and over 100 women training in the town. Rosefield Mill, which was used for a time as a recruiting station, served as a barracks until larger barracks were built at Carronbridge to accommodate them.

In 1941, Noel Dinwiddie, a printer and stationer with premises in the High Street near the Midsteeple, and Major Olaus Myrseth, who was billeted at the Station Hotel, set up The Scottish Norwegian Society. Its objectives were 'to promote friendship, and to further cultural and commercial relations between the Scottish Norwegian peoples'. Part of an

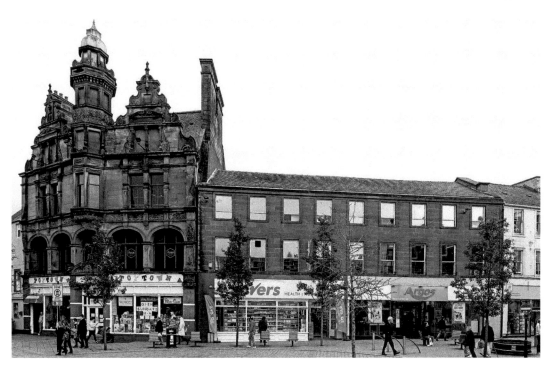

Norges Hus: headquarters and cultural centre for exiled Norwegians.

empty building in the High Street was used for workshops and stores; the remainder was home to the new society. Called Norgus Hus, it had a library, was used for concerts, lectures and hosted exhibitions on Norwegian life. Around forty Doonhamers took up the offer of language classes.

Travel restrictions had put a stop to football, so there was great enthusiasm when a game between the visitors from Norway and Queen of the South was organised. It turned out to be a crushing defeat – and not the only one – for Queen of the South. The Norwegians had not mentioned that nine members of their team had been runners-up in the finals of the Oslo Olympic Games.

The Norwegians were fully integrated into Dumfries society, from frequenting local pubs to worshipping in local churches, especially Troqueer Church to which they gifted a baptismal bowl, and St Michael's, which received a plaque and pulpit robes. Dumfries girls also helped the integration process and there were a number of romances and marriages.

Town clerk James Hutcheon summed it up, saying, 'They were never just a colony within a foreign town for they entered into the life of the community bringing a robust, self-reliant vibrancy to the stirring time of war.'

Long after the war the links continued between Norway and Dumfries with many exchange visits including tours of Norwegian youth football teams and visits to Norway by local club Greystone Rovers. King Olav V visited Dumfries in October 1962 and was granted the freedom of the burgh.

6. Outdoor Art Gallery

Dumfries is well served with museums and galleries including Gracefield Arts Centre on Edinburgh Road. It houses a collection of Scottish paintings, including some by the Scottish Colourists, the Glasgow Boys, the Kirkcudbright School and the Edinburgh School, as well as contemporary Scottish works of art by the likes of Joan Eardley and Andy Goldsworthy.

Many people strolling along the Whitesands beside the Nith don't notice the unusual finials on the railings; others stop to puzzle over them not realising they are walking in the middle of a public art gallery. Various art pieces pay tribute to the river's significance in the town's heritage. Although the artworks are in full public view, and therefore no secret, visitors to the town as well as many local people are unaware of their existence.

The finials, thirty-eight in total, were designed and created by Natalie Vardey, better known for her exquisite jewellery. Made in steel, copper and bronze, with stainless-steel revolving mechanisms, these small-scale artworks link to past and present trades in Dumfries. The shuttles and whistles represent the weaving trade. The whistles, decorated with clogs, horseshoes, threads and spools, called the women to work, who would then clatter over the suspension bridge in their clogs to the tweed mills. Salmon fishing and the tourist trade are represented by the fish. The sails are a reminder of the metalwork trades including the cargos of iron ore coming into the town while the fouled anchor was the hallmark for the town's jewellers and silversmiths.

Telescope finial.

Above left: Anchor finial.

Above right: Basket finial.

At one time all guildsmen were legally obliged to demonstrate competency in archery and shooting and the bow and arrow finials are a reminder of those days. The spires represent the church and law courts while the keyhole endplates represent the blacksmiths who looked after the town clock, made locks, keys and looked after farm machinery. The eyeglass finial, opposite the Camera Obscura on the other side of the river, signifies how the trades have been reduced over the years.

Two large kinetic hangings were created by artist Ken Grierson. The colourful hangings represent sunset and sunrise over the Nith, shimmering in the slightest breeze. Close to the hangings, artist blacksmith Adam Booth's creation comprises a railing, a small gate upstream and a bench. The work is a direct link to the river and how the water flows around solid objects. All the horizontal sections float on pins and the gates in the railing have no visible hinges. That it has survived in what is a very hostile environment with no maintenance is due to the quality of its design and construction. The bench, which is gradually disappearing under the sand that is building up on the edge of the river, is a reference to Devorgilla's bridge with the arches and water flowing through it.

Matt Baker's granite sculpture of Lady Devorgilla is further on towards the Devorgilla Bridge. She is set into the sandstone wall, looking across the river. The figure was inspired by Lady Devorgilla Baillol, who reputedly had the first wooden bridge across the bridge built in the thirteenth century. She was the daughter of Alan, Lord of Galloway and married John Balliol when she was only thirteen. In her own right she was a wealthy and powerful woman. Although her husband founded Balliol College, Oxford

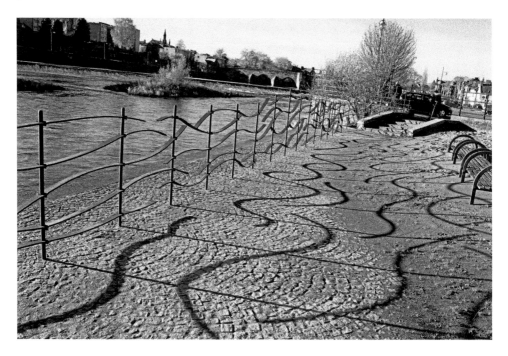

Railings created by Adam Booth.

(for poor scholars), she made a permanent endowment to the college to secure its future. She also founded Greyfriars Monastery in Dumfries. On the death of her husband she established a Cistercian Monastery at New Abbey, a few miles from Dumfries. She had his heart embalmed and carried it with her in an ivory casket. When she died she was buried at the abbey church she had founded, with her husband's heart beside her. Is this a romantic tale, or is carrying your dead husband's heart around a bit weird? The monks clearly decided on romantic, calling the abbey *Dulce Cor*, meaning 'sweet heart'.

Now, carved in granite from salvaged harbour kerbs, Devorgilla stands gazing serenely across the caul. When the River Nith floods, which it does frequently, the sculpture is partially submerged and becomes part of the river in a powerful way.

Originally, a second part of Matt Baker's installation was situated on the other side of the river. It was a translucent etching of a woman about to cross the river, laminated in glass with an oak frame. She was there for nine years before being destroyed in 2007 by spring floods.

People can have a bit of fun with the statue of a Dumfries local hero. A round plinth, situated before the public toilets, has a pair of footprints set on top. Here, anyone can stand and enjoy being that Dumfries local hero.

Another public artwork can be found at the junction where Friars Vennel crosses Irish Street. Friars Vennel has existed since the tenth century and has had a significant role in the town's history. It's a narrow street which runs down from High Street to end at the Whitesands, where once there was a ford across the river. It was the main thoroughfare for pilgrims, including Scotland's kings and queens heading to worship at St Ninian's shrine at Whithorn. It was also the route used by immigrants from Ireland

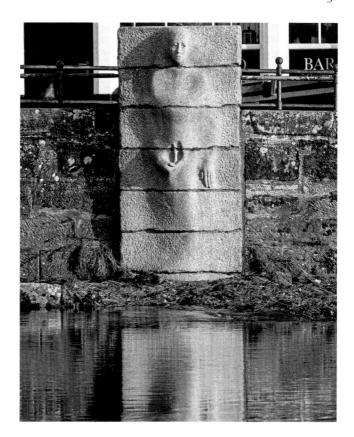

Right: Devorgilla sculpture.

Below: Devorgilla's head detail.

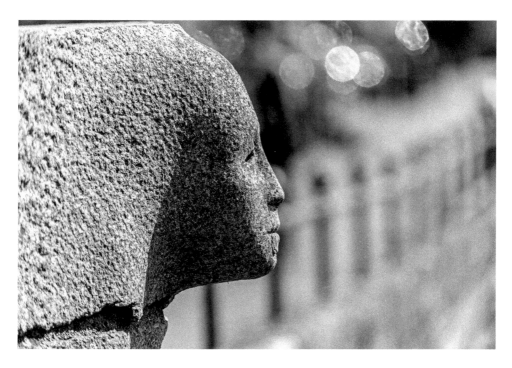

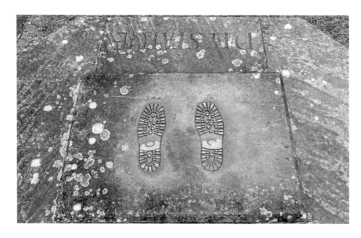

Local hero plinth.

and invading armies during the English Wars. The Greyfriars Monastery, founded by Lady Devorgilla, was at the top of the Vennel.

Many Doonhamers remember the Vennel as being a busy shopping street, but as shopping patterns changed in Dumfries it became rather rundown. The local council had some funding for a regeneration project, which included resurfacing part of the street. They had considered putting in public seating but, according to architectural artist Will Levi Marshall, who was commissioned to create a sculpture, there were worries about what kind of people would congregate there. Will was rather pleased to hear the sculpture occasionally has some appeal to skateboarders.

The sculpture is called *Myndin the Fuird* (Remembering the Ford). The idea behind it is to get people to honour the river and acknowledge its importance to the town. It was an important boundary and we should not let our heritage be lost or forgotten. Will approached poet Rab Wilson to write some lines of poetry to be included referencing the river.

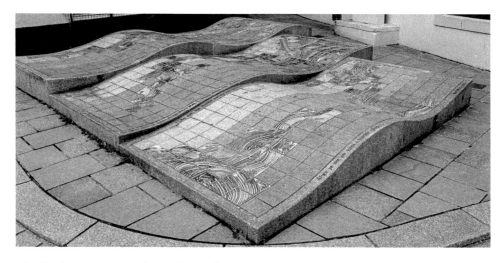

Myndin the Fuird (Remembering the Ford).

7. Remarkable Doonhamers

Many Doonhamers – John Laurie of *Dad's Army* 'We're doomed' fame for instance and others who moved into the town such as Robert Burns – have made their mark nationally and internationally. However, there are more than few who are not so well remembered nowadays despite their achievements, and others who have slipped into obscurity.

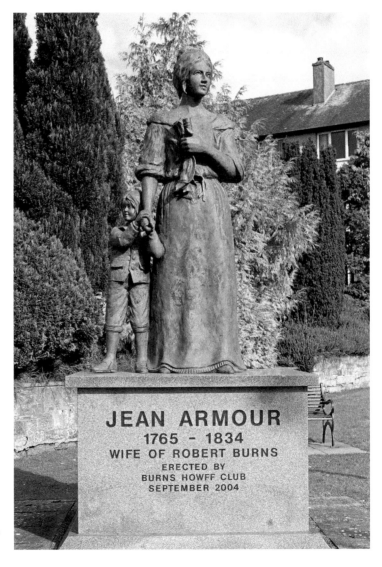

JEAN ARMOUR
1765 – 1834
WIFE OF ROBERT BURNS
ERECTED BY
BURNS HOWFF CLUB
SEPTEMBER 2004

Robert Burns's wife
Jean Armour opposite
St Michael's Church.

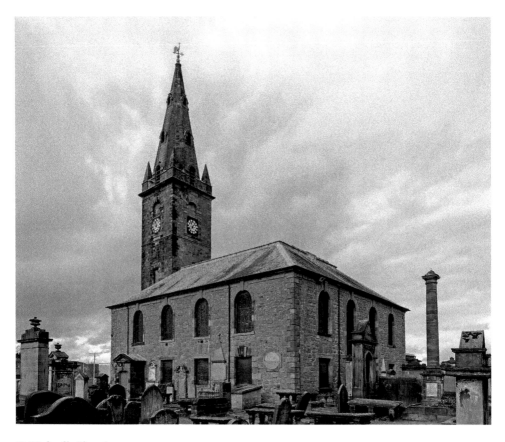

St Michael's Church.

William Peck

Although not a native of Dumfries, William Peck died in the town and is buried in St Michael's churchyard, in the military corner to the left of the entrance. The words on his flat gravestone are scarcely legible now and don't give much hint of the incredible story behind them. It reads, 'In memory of William Peck, Esquire, late Surgeon of the King's Own or 4th Regiment of Foot, a man of amiable character and good dispositions, eminent and useful in his profession. He deceas'd at Dumfries the 11th day of January 1769, in the 52nd year of his age. This monument is erected by Robert Riddick, Esq. of Corbeton, as a testimony of friendship, and in gratitude for valuable professional services.'

Robert Riddick's wife had a serious problem with her leg, described as a 'dangerous malady' which no physician could alleviate. One night she dreamed that someone saved her life by amputating her leg. In the morning she told her husband of her dream, describing the man who had carried out the surgery. Some weeks after this, the King's Own Regiment, or 4th Regiment of the Foot, came to Dumfries. Crowds lined the street to watch them march through. Amongst the crowd were Mr and Mrs Riddick and she recognised William Peck as the man who had appeared in her dream. Her husband approached the surgeon, who agreed to examine Mrs Riddick's leg.

William Peck's grave.

As in her dream, the only solution was to amputate. She must have been in agonising pain to undergo such treatment. This was before anaesthetic was available and when the risk of dying from infection was extremely high. The surgery was successfully carried out; Mrs Riddick survived and went home restored to health.

Some years later, Mr Peck, still serving with the regiment, took ill and, hoping a change of air would aid his recovery, returned to Dumfries to visit the Riddicks. Here he died and was buried in St Michael's under the monument erected by a grateful Mr Riddick.

DID YOU KNOW THAT...?

William Patterson (1658–1719), founder of the Bank of England, was from just outside Dumfries. In 1691 his proposal to the English government for the formation of a national bank was accepted. In 1695, he moved to Edinburgh and founded the Bank of Scotland. He was the instigator of the ill-fated Darien scheme to find a trading colony on the Isthmus of Darien (now Panama) in 1698. It was a disaster for Scotland. Over 2,000 people died and Scotland was left almost bankrupt.

Thomas Wilson (1760–1825)

A few years before the death of William Peck, Thomas Wilson, better known in his day as Blin' Tam, the bell-ringer, was born in Dumfries on '06 May 1760 old style' (according to the Julian calendar). He lost his sight after contracting smallpox at such a young age

that he reportedly had no memory of ever seeing anything of the world. Despite this impairment, by the time he was twelve years old he had taken on the role of chief bell-ringer at the Midsteeple. His starting salary was the sum of thirty shillings, which gradually rose through the sixty-three years he held the job to £20 a year.

He supplemented his income by becoming a skilled woodturner, making beetles and spurtles which were much sought after by the town's housewives. He grew his own vegetables and cooked for himself. He even cut peats. By all accounts Tam had an incredible memory, knowing his way round the town, even guiding strangers to where they wanted to go – strangers who did not even realise Tam was blind until they reached their destinations.

When the old weathercock was replaced by a new one, Tam climbed the ladder to the top to welcome the bird by embracing it and saying he hoped it would indicate the winds as truly as he did the time of day. He kept an old fowling gun, which he took with him to the high leads of the steeple where he fired several rounds to celebrate the birthday of George III.

He rang the bell more than 100,000 times and he only once made a mistake, one night ringing eleven instead of ten. By way of explanation he declared he must have been a bit 'fey' that night.

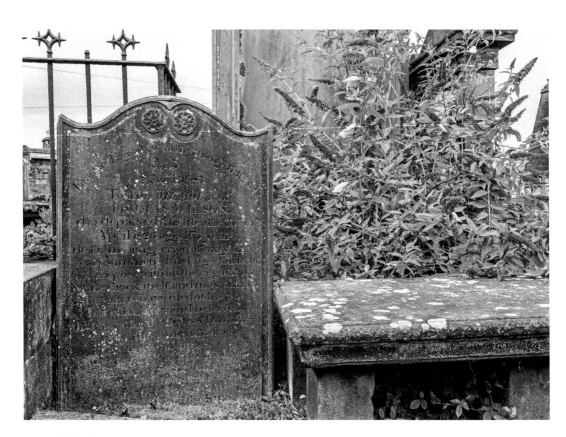

Blin' Tam's gravestone.

Poor Tam had a sad end to what seems to have been a happy life. On 12 March 1825 when he was in the belfry he fell, possibly as the result of a stroke, cutting his head on an old chest. He was barely conscious when discovered the next morning by his assistant. He was taken, still breathing but unable to speak, to his home where he died shortly afterwards.

DID YOU KNOW THAT...?

The body of Poet Robert Burns was dug up twice. The first time was in 1815 when his body was moved from its original, unremarkable resting place in St Michael's churchyard to be reinterred in the mausoleum. The second time, in 1834, was the night before the burial of his widow, Jean Armour. Phrenology was very much in vogue in the nineteenth century and a plaster cast was made of his skull so they could assess the poetic bumps.

Sir John Richardson (1787–1865)

John Richardson was born in Nith Place, Dumfries. His father was Gabriel Richardson, a successful brewer. John's illustrious career as a doctor, surgeon, Arctic explorer and knowledgeable botanist led to a knighthood from Queen Victoria in 1846.

He was apprenticed to a local surgeon when he was thirteen, before going to Edinburgh to study medicine. From 1804 he worked at the infirmary in Dumfries for two years. He joined the Royal Navy, becoming assistant surgeon on the frigate *La Nymphe* and spent several years at sea during the Napoleonic Wars. When he had settled back on shore, the Admiralty asked him to join an Arctic expedition led by Lieutenant John Franklin. Leaving in May 1819, they arrived at the Hudson's Bay Co.'s post at York Factory where they spent the winter before pushing on next spring. The second winter was spent at Fort Enterprise then Richardson and Franklin with a party of voyageurs portaged to the Coppermine River and down it to the Arctic. In an open boat they continued east for some 500 miles.

The return journey to Fort Enterprise was difficult. An argument with the voyageurs left them without canoes when they reached the Coppermine River. Richardson nearly died trying to swim across; one of the group was shot by a Métis (a person of mixed First Nation and European race) who went mad and had to be shot by Richardson, and the party was close to starvation, resorting to chewing moss and shoe leather before being rescued by a party of Indians.

On a second expedition Franklin Richardson explored and charted over 1,000 miles of coastline. After this, he settled at home to write up his notes and in 1837 published four volumes of *Fauna Boreali-Americana*.

Franklin had embarked on a third expedition in 1845 to try to navigate the Northwest Passage but had failed to return by late 1847. In the spring of 1848 Richardson set off with other

Arctic experts but found no trace of Franklin and his crew. It was learned later they had died before the Admiralty sent out its search party. Richardson retired from the Navy at sixty-eight.

The Royal Society presented him with a medal for his work in zoology, geography and meteorology. In his books he wrote about many species of mammals, fish and birds, some of which were unknown before. In the Northwest Territories, his name has been given to a group of islands, a range of mountains and many birds and animals, for example Richardson's ground squirrel and Richardson's owl.

Miss Jessie McKie (1829–1907)

Although Andrew Carnegie donated the funds (£10,000) for its construction and it was named after William Ewart, a former MP for Dumfries responsible for the Free Libraries Act, it was Miss McKie and her brother who donated the land on which the Ewart Library was built in Catherine Street.

Jessie McKie's father, William McKie, was 'an extensive manufacturer and commission agent', which clearly made him wealthy and well respected in the town. He was Provost of Dumfries from 1827 to 1829. On his death in 1838, Jessie and her brothers inherited what must have been a considerable fortune.

She donated money to the town council in 1891 towards the widening of the Buccleuch Bridge (or New Bridge as it was then called), as she was 'greatly distressed' by the number of accidents that occurred on the narrow bridge. She also funded a public laundry and public baths on the Greensands. Although particularly concerned about the welfare of the town's poor, she also cared for animals, gifting a granite horse trough at the top of the Whitesands, which reads, 'A righteous man regardeth the life of his beast.'

Horse trough.

Silver Burgess
casket.

According to her obituary in the *Dumfries & Galloway Standard*, 'it was an entertainment and an education to be in the company of Miss McKie'. She travelled widely, was a great reader and had 'a lively sense of humour'. She was interested in politics and was a supporter of her brother Thomas, who tried several times to win the county seat for Home rule.

She became the proprietor of the Theatre Royal, possibly after the death of her brother William McKie, who, when he was proprietor, spent some £3,000 on refurbishments of the theatre in 1876. She had a private box and was a regular attender. On her death the theatre performance was cancelled out of respect.

Better known in her lifetime than now for those and other good works for the town, in 1897 Jessie McKie was presented with the Freedom of the Burgh. She was the first, and to date the only, woman to receive the honour.

She made many bequests to charitable organisations in her will including £500 to the infirmary, £100 to the Dumfries Industrial School for Boys (but only £50 to the girls' school) and the sum of £3,000 to the trustees of what was to be called the Miss McKie Fund for aiding the 'aged, infirm, and indigent women of Dumfries and Maxwelltown'.

Patrick Miller (1731–1815)
Glasgow-born Patrick Miller was a banker and shareholder in the Carron Iron Co. He was greatly interested in naval architecture and designed a warship in which he hoped European navies might be interested. Only Sweden showed some interest in the double-hulled ship with a paddle wheel called *Experiment*, which Miller gifted to King Gustav III around 1791. In return, the king sent Miller a magnificent gold snuffbox which bears the king's portrait on top and a painting of the ship on the base. Inside was a packet of seeds. Thus, the vegetable known as the swede was introduced to Scotland. The snuffbox is in the Victoria and Albert Museum, London.

Miller may have been one of the three men credited with the design of the carronade (Charles Gascoigne and General Robert Melville), a new type of cannon made by the Carron Iron Co., which has a shorter barrel but the same calibre as longer guns. It was a vast improvement on previous models, which were so despised by the Royal Navy it removed them from all their ships.

In 1785, Miller bought, without actually seeing it, the rundown Dalswinton Estate, 7 miles from Dumfries. On his first visit, he was dismayed to find the place 'in the most miserable state of exhaustion and all the tenants in poverty'. He set about transforming it, building a new mansion, planting woodlands and developing the village of Dalswinton. He introduced a drill plough and a new kind of threshing machine – and, of course, he grew swedes, which proved excellent cattle fodder. His next agricultural experiment was to introduce fiorin grass after he had been introduced to the Revd William Richardson of Clonfeckle in Ireland, who was a passionate advocate of fiorin grass. Miller even built, in 1810, a tower to the Revd Richardson – a round tower near, appropriately, Clonfeckle Farm. The locals, less than impressed with both the grass and the tower, referred to it as Miller's Maggot, suggesting the landowner had a maggot in his brain.

Miller's biggest dream was to develop the first paddle boat powered by steam. He excavated Dalswinton Loch to enable him to conduct his experiments. He was introduced to mining engineer William Symington and the pair worked together on the project. Symington was tasked with the responsibility of modifying one of his steam engines

The boat.

Dalswinton Loch.

to drive Miller's 25-foot-long paddle boat on the Loch. Full of enthusiasm, Miller wrote, 'I have reason to believe that the power of the steam engine may be applied to work the wheels. ... In the course of this summer I intend to make the experiment, and the result, if favourable, shall be communicated to the public.'

The experiment took place on 14 October 1788 on Dalswinton Loch with, reputedly, Miller's tenant poet Robert Burns, who was farming at Ellisland, on board. During the trial the boat achieved a speed of 5 mph – the first steamboat in the world. A replica of the boat sits by Dalswinton Loch and the engine is in the South Kensington Museum.

John (Jock) Law Hume and Thomas Mullin

These two young Dumfries men perished when the *Titanic* sank. Jock was a talented violinist who played with the ship's band. Thomas was a third-class steward. As boys, both had attended St Michael's Primary School and both are buried in the same cemetery in Halifax, Nova Scotia. Their memorial, a granite obelisk, was unveiled in 1913, in Dock Park. Although not on duty when the order came to abandon ship, Jock and his fellow bandsmen went on deck and continued to play until the ship went down. Survivors reported that the last piece of music the band played was the hymn 'Nearer, My God, To Thee'. He was only twenty-one and left behind his pregnant fiancée, Mary Costin. His daughter was named Johnann Law Hume in his memory. His friend Thomas was twenty when he lost his life. In *And the Band Played On* Jock's grandson Christopher Ward has written a moving account of both the tragedy and how lives were affected afterwards.

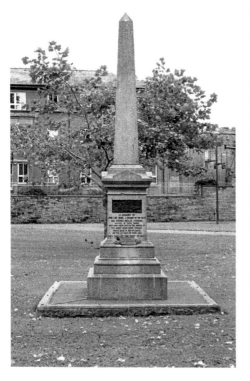

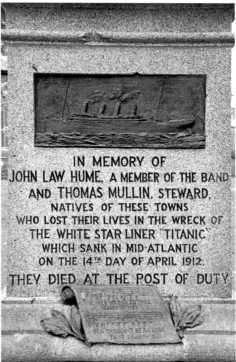

Above left: *Titanic* monument.

Above right: *Titanic* plaque.

DID YOU KNOW THAT...?

Apart from Jock Hume and Tom Mullin, a third person from Dumfries had a connection to the *Titanic* disaster. Twenty-eight-year-old Mr William Burdall was a waiter on board the RMS *Carpathia*, the first ship on the scene to rescue survivors of the *Titanic*.

Robert Louis Waland (1908–99)

It was thanks to a Doonhamer that Neil Armstrong was able to find his way around on the moon in 1969. Robert Louis Waland designed and constructed the 61-inch reflecting telescope for planetary research, which was used to map the moon for the Apollo programme.

Waland was born in 1908 and attended Dumfries Academy. An enthusiastic astronomer, he built his first telescope lens when he was sixteen. Three years later, entirely self-taught, he constructed a solar-camera telescope to view the 1927 total solar eclipse. He cycled 150

Astronomer Robert Louis Waland.

miles to Richmond in Yorkshire, carting the camera. Unfortunately, clouds hid the crucial moments though he was able to take photos of the sun's disc before and after the total eclipse.

He continued to design and construct refracting telescopes incorporating cameras to photograph the stars. In 1945 Professor Erwin Finlay-Freundlich, impressed by Waland's work, appointed him to the post of head technician in the Department of Astronomy at St Andrews University where he built the revolutionary Schmidt-Cassegrain telescope, which could photograph stars millions of light years away.

It was when he became a research associate at the Lunar and Planetary Laboratory in the University of Arizona in 1962 that Waland's work was linked to the American space programme. The asteroid 3734 Waland was discovered in 1960 and named after him.

Alfred (Alf) Edgar Truckell (1919–2007)

Very few people in Dumfries with an interest in local history will not be familiar with the name Alf Truckell. He was the curator of Dumfries Museum from 1948, a post he held until he retired in 1982, more than tripling visitor numbers and amassing thousands of items for the collections.

Born in Barrow-in-Furness in 1919, Alf moved to Dumfries when he was a child, attending Noblehill Primary School. Unfortunately he was forced to give up writing with his left hand, a traumatic event that left him with a stammer for many years. When he left Dumfries Academy he worked for a time at Dinwiddie's printworks before becoming

a junior clerk in the Town Clerk's office where he remained until the outbreak of the Second World War. He served, firstly in the UK, with the Pay Corps before being sent overseas in 1942. He met and married his wife in Egypt.

Back at the Town Clerk's office after the war, Alf was asked to index Town Council and Committee Minutes, something which had been neglected since the early 1920s. His enthusiasm for local history was recognised with his appointment in 1948 as curator of Dumfries Museum. The breadth and scope of his interests was wide-ranging and he had an encyclopaedic knowledge of natural history, archaeology, history and folklore. In 1952 he was awarded the Diploma of the Museums Association.

Not only did Alf increase visitor numbers; he took on the curatorship of the Old Bridge House Museum, which is now a museum of Dumfries domestic life. He also started a museum in Annan. Among his many thousands of acquisitions are several sandstone slabs bearing the fossilised footprints of primitive reptiles that predated the dinosaurs. One of those type specimens was found in Corncockle Quarry and is named after Alf. Called *Prochirotherium truckelli*, it is on permanent display in the main hall of the museum.

He encouraged school visits to the museum and local monuments and archaeological digs, and, having overcome his stammer, he taught extra-mural classes both locally in Thornhill and at Glasgow University. He was awarded an MBE for his services to learning in 1970. His energy and enthusiasm were boundless whether it was for arranging in-season plant displays or excavating the tenements and close clearance schemes of the 1960s and 1970s – and he enthused others in turn. He retired in 1982 but continued to work on local history research until his death in 2007.

Dumfries Museum and Observatory.

8. Remember to Look Up!

While admiring the architecture of the fine sandstone buildings, it pays to remember to look up so you don't miss some fascinating things above our usual line of vision. As you walk towards the Midsteeple on High Street, just after the junction with Bank Street, look up to see three carved heads looking down on you from a building on the left.

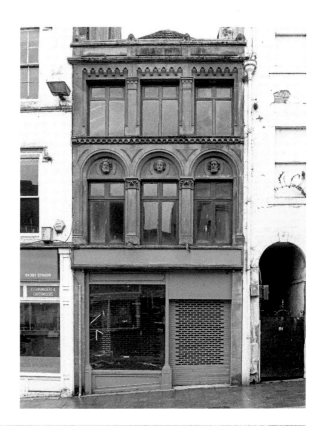

Right: Once home to *The Courier* established by Henry Duncan.

Below: Close-up of the three heads.

It was here in 1809 that the Revd Dr Henry Duncan, minister of Ruthwell and founder of the savings bank, established the *Dumfries and Galloway Courier*. He owned and edited the newspaper until 1817 when John McDiarmid took over the editorship.

At the other end of High Street, just before the Hole I' The Wa Inn, which was established in 1620 and is one of the oldest pubs in the town, look up to see a fire mark high on the wall above a closed-down shoe shop. These fire marks are quite rare now but were common in the seventeenth and early eighteenth centuries, indicating the building that bore the mark was insured against fire.

Their history goes back to after the Great Fire of London in 1666 when it became obvious a more organised approach to firefighting was required. The world's first property insurance company, established by a man called Nicholas Barbon in 1667, was called the Fire Office. A private company, it provided money for the restoration or reconstruction of buildings damaged by fire. This later became known as Phoenix Fire Office. Other insurance companies were formed and soon realised it was more cost-effective to fight fires than pay out for the reconstruction of damaged buildings.

The insurance companies set up their own fire brigades and these would put out fires on those buildings that were insured. Each company had a different symbol and these fire marks, with the insurance policy number beneath the logo, were fixed to the walls to designate which were covered under which company's policy. Apparently it was not unknown for a fire in an insured property to be put out while the next door building with no fire mark on display was left to burn.

As you walk past Greyfriars Church look up to admire its neo-Gothic architecture. The plans were by John Starforth of Edinburgh and the imposing, ornately carved steeple is 164 feet in height. The land on which the church sits was once the site of Maxwell's Castle. A church was built here in 1727 called New Church. The cost of the building, £1,970 Scots, was raised through a tax on beer brewed in the town. By 1865 the church was in need of

Fire mark.

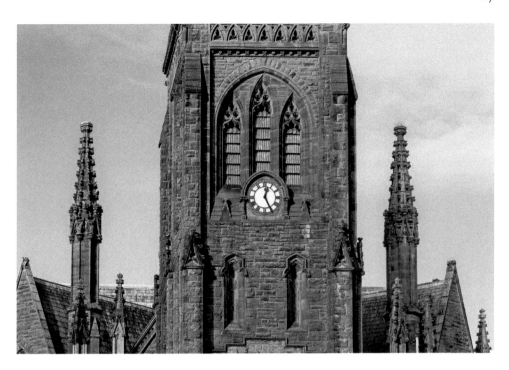

Above: Greyfriars church.

Right: Greyfriars church spire.

renovation and, unfortunately, when the costs were discovered it was decided to pull it down and start again. The foundation stone was laid in 1866 and the church, now called Greyfriars, opened in 1868.

In 2004, the congregation amalgamated with St Mary's and Greyfriars lay empty until bought in 2008 by a Dumfries man living in London. Andrew Crosbie, an ordained minister, is a descendent of Dumfries provost John Crosbie, who put the tax on beer to raise funds for the previous church and wanted to ensure the church continued to be a place of worship.

Continuing along Church Crescent, you will find a statue to the Revd Henry Duncan (1774–1846) on the former Dumfries Savings Bank building. He was minister of the parish church in Ruthwell, around 10 miles from Dumfries, for almost fifty years and was an extraordinary man with many skills and interests including science and geology. He presented a paper to the Royal Society in Edinburgh on his identification of the first fossil footprints in Britain, which he discovered at Cornockle Quarry, near Lochmaben. He founded two newspapers, the *Dumfries Courier* in 1809 and the *Dumfries Standard* in 1843, local newspapers which were to bring news of the world to the people of the district.

The early 1800s was a time of hardship for Henry Duncan's parishioners. Several bad harvests led to terrible deprivation. He revived the Friendly Society, which guaranteed cash to support members faced with loss of earnings because of illness or accident. He determined to bring financial independence to the people by 'the erection of an economical bank for the savings of the industrious'. In 1810 he founded the world's first commercial savings bank, which paid interest on investors' savings, in the village of Ruthwell.

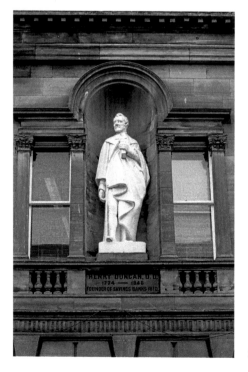

Statue of Henry Duncan.

Based on business principles, its operation could be adopted universally. Villagers trusted him and banked the few pennies they had spare; wealthier parishioners also deposited cash with the bank and at the end of the first year the bank's funds were at a total of £151. Within five years, savings banks based on the Duncan model had opened throughout the United Kingdom. The building in Ruthwell where Henry Duncan opened the first ledger is now the Savings Bank Museum.

He also restored the Ruthwell Cross. This preaching cross, believed to have been created around AD 664, was destroyed in 1642 by the Reformed Church of Scotland, which wanted no iconography in its churches. When Revd Duncan unearthed parts of the cross buried in the garden of the manse he realised their importance and spent twenty years restoring the 18-foot cross with its runic carvings thought to depict Caedmon's poem *The Lay of the Holy Rood*. The cross is now in Ruthwell Church, which had to raise the height of the roof to accommodate it.

Shortly after Henry's death in 1846, his brother Thomas commissioned a new building for the Dumfries Savings Bank and the statue of Henry. It is 8.5 feet high, carved by a local man named J. Currie. The £80 cost was raised by public subscription.

There is some wonderful carved detail above a building with another banking connection: the National Bank of Scotland, near the foot of Bank Street.

On English Street, the three-storey red-sandstone corner block at Nos 57–61 is not perhaps the most attractive of the town's nineteenth-century buildings. It was built in 1887 and named Jubilee Building in honour of Queen Victoria's Golden Jubilee. Retail units take up the ground-floor space while nowadays the upper floors are unoccupied. The reason for looking up is to see the bust of Queen Victoria at first-floor level in the centre bay. She has presided over many changes of use of the premises through the years.

Around 1910, No. 57 English Street was known as the rather amazing-sounding County Toilet Club, a 'High Class Hairdressing Establishment for Ladies and Gentlemen'. The ladies had a separate room and the advert went on to assure everyone of 'Antiseptic Treatment of all Appliances'. In the early part of the twentieth century a photographic studio occupied the top floor, which had big skylight windows on the north side of the roof. The last hansom cab business in Dumfries operated from the premises but probably what most Doonhamers will best remember is the Jubilee Building being occupied by Percy Bros. This family-run electrical business was a familiar name in the town for almost sixty years before it finally closed in 1994. Lynn Watt, whose family owned the business, remembers the adverts her father had playing in the local cinema. She said, 'My father was given free tickets every week that an advert was running in the cinema. I do remember cringing in my seat at many of them – especially in the 1970s. Really cheesy – but a small price to pay for free films!'

Fine detail of carving above old National Bank of Scotland.

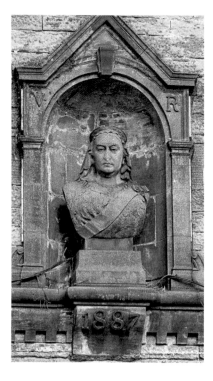

Queen Victoria.

Queen Victoria, unfortunately, is now looking the worse for wear. Her nose has crumbled and she is festooned with moss and weeds, and she would probably not be amused about the pigeons that perch on her head.

George Street is Dumfries's 'New Town'. The empty and now somewhat derelict buildings on the corner were once home to the original Technical College. From 1994, The George Street School of Art and Design occupied the building until 2008 when it relocated to the Crichton Campus.

Just past the old college site, the first building on George Street is now occupied by Dumfries toy library Playworks and two unions, Unite and Unison. Look up as you pass to see the Masonic sign above the door. The premises, built by the Saint Michael's Lodge as a Masonic Hall in 1890, were occupied by both Thistle Lodge and Kilwinning Lodge No. 53. The architect was Alan Burgess Crombie, who also designed the Ewart Library.

The Masons only stayed until the beginning of April 1901 when they were given notice to quit. The history page on the Thistle Lodge website quotes from the minutes, 'A notice which had been served upon the secretary by the proprietors of the Masonic Hall intimating that our tenancy of the hall would terminate at Whitsunday next, and that we would then require to remove from the premises'. The action was taken 'in consequence of our refusal to comply with absurd and extortionate demands for increased rent by the proprietors of the hall'. Within a couple of weeks, alternative premises at the same annual rent of £8.00 were found in the hall and anti-rooms of the Congregational Church on Irving Street, just around the corner from the current home of the Lodges in what was once the Assembly Rooms.

Former Masonic Hall, George Street.

Close-up of Masonic symbols and fine decorative detail.

Across from the Assembly Rooms is a building which is no longer a secret, though for many years it was neglected and ignored. Moat Brae was designed in 1823 by local architect Walter Newall for Robert Threshie, a solicitor. The house changed hands several times and at one point belonged to Henry Gordon. His two sons, Henry and Stewart, attended Dumfries Academy where they became friendly with James Matthew Barrie. It was while playing at pirates in the garden at Moat Brae that the seeds for Neverland were planted.

The house passed out of private ownership and became a private hospital and nursing home. A businessman from Paisley bought it but, unable to secure the funding to turn it into a themed hotel, he sold it to Loreburn Housing Association. In 2009 the association planned to demolish it and build affordable housing on the site. The Peter Pan Moat Brae Trust was formed to save and restore the building and garden. The latter will include the Jolly Roger Pirate Ship and the Mermaid's Lagoon. It is hoped Moat Brae will be open by the end of 2018 ready to inspire and stimulate the imaginations of twenty-first-century children. It is when Moat Brae is open to the public the reason for looking up will become clear: the stunning circular first-floor gallery and domed glass roof.

If all the looking up is causing neck strain, don't forget to look down, too. On the west side of Devorgilla Bridge is the Old Bridge House Museum. Sitting on the parapet of the bridge, leaning against the wall of the museum, is a large carved stone slab depicting the Tree of Life, with letter I or figure 1, and traces of other letters. It stands around 2 feet 9 inches high and 3 feet across the base. It originally came from above the doorway of a house built into the east (Dumfries) end of the Old Bridge. The house was demolished in 1795 when the bridge was shortened.

The dome above the entrance hall, Moat Brae.

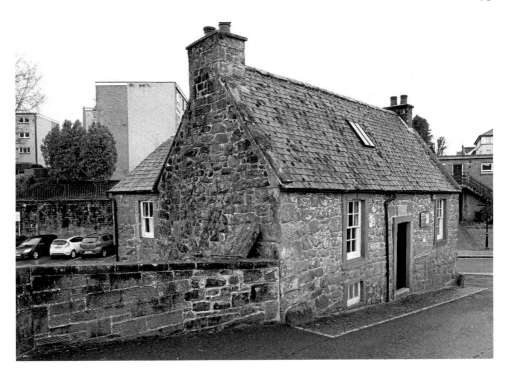

Old Bridge House.

Rescued Tree of Life stone.

Old Bridge House is the oldest house in the town, built in 1660 by James Birkmyre, a cooper. It has been suggested the premises may have been used as a meeting place by Covenanters but it hardly seems the safest of secret meeting places. During much of the 1700s and into the 1800s the building was used as an inn. In the 1880s, it became a private home. Now a museum of everyday life, it has a huge and fascinating collection of artefacts.

One more point of interest most people walk past without noticing is in Queensberry Square. Look down as you go by the TSB Bank to see a plaque indicating the site of a medieval well. Also in Queensberry Square, underground and inaccessible, are parts of the old vaults from the New Wark Castle, a tower house built in 1440 by Sir Herbert Maxwell. Dumfries town bought the castle in 1720 and demolished it in 1727.

Oh, and the old underground gents' lavatories, which were removed in the mid-1930s, may also be down there – nobody seems to know for sure.

Plaque showing site of medieval well.

9. Recreation

Dumfries is often referred to as the Queen of the South, which is the name given to its football team, the only football team mentioned in the Bible. The Queen of the South in the Old Testament is the Queen of Sheba (Chronicles 9:1): 'Now when the Queen of Sheba heard of the fame of Solomon, she came to Jerusalem to test Solomon with difficult questions.' The Queen of the South (Queen of Sheba) is also mentioned in the New Testament in Luke (11:31).

Perhaps one of the difficult questions was how did Queen of the South allow Willie Sharp of Partick Thistle to score against them in just seven seconds in 1949, the quickest ever goal to be scored in the history of Scottish League Football? Or, maybe the question would be regarding the players' eyesight the first time floodlights were used at Palmerston and Preston North End beat Queens 5-0 on 29 October 1958.

A meeting was held in Dumfries Town Hall on 21 March 1919 to plan a football team that would play competitive football at more than a local level. A merger of three clubs from Dumfries and Maxwelltown – Dumfries Football Club, 5th King's Own Scottish

Plaque on Old Bazaar pub commemorating the ninetieth anniversary of first formal meeting of Queen of the South.

Queen of the South football stadium.

Borderers football team and the team from the Arrol-Johnston Car Co. – created the new team of Queen of the South. Palmerston Park, which was already a football venue (and a Bronze Age burial site), was chosen as the club's home. The first game, a 2-2 draw with Nithsdale Wanderers, took place on 16 August 1919. In 1923, Queen of the South was first admitted to the Scottish Football League.

One of the most exciting times was in 2008. For the first time ever a Queen of the South match was telecasted live when the team played Premier League side Aberdeen in the semi-final of the Scottish Cup – and beat them to a place in the final. They lost 2-3 to Rangers in a hard-fought final. Even so, 14,000 fans turned out to cheer the team in an open-top bus parade through the town.

The same number of people turned up in October 1899 when Barnum and Bailey brought the circus to town. The performance was held in an enormous tent at Cresswell but beforehand the animals were paraded through the streets of Dumfries. The great parade included camels, zebras, hyenas, leopards, lions, tigers and elephants. Over the years a number of elephants have appeared in circuses around Dumfries and Galloway, leading to tales of dead elephants being buried in all sorts of places from Dock Park to a field beside the A75.

DID YOU KNOW THAT...?

In sixteenth-century Dumfries the townspeople wore green and carried arms when the annual May Play took place. The two who took the parts of Robin Hood and Little John were the Lords of Misrule with complete power in the town. In 1570, a man called Thom Trustre was fined for refusing to take on the role of Robin Hood.

Dumfries has had several cinemas. The Regal opened in 1931 on Shakespeare Street with seats for 1,700. In 1972, it was split into two: one part continued as the ABC cinema with the number of seats greatly reduced to 526 and the other part became a bingo hall. It is now called the Odeon.

Near the foot of High Street, a new cinema was opened on 4 October 1936. The Lyceum was built on the site of the Old Lyceum Theatre and designed to seat an audience of 2,000. As well as being a cinema, it was equipped to be able to offer live shows. It closed in late 1969 and both this and adjacent buildings were demolished in 1970 for a new supermarket.

Dumfries still has two cinemas: the Odeon and the Robert Burns Centre in an eighteenth-century watermill on the riverbank. The centre tells the story of the poet's years in Dumfries through an exhibition of original manuscripts and belongings of the bard and an audio-visual presentation. In the evenings, it shows films in a fully accessible auditorium.

Theatre Royal.

Still on the subject of film, Dumfries has been the location for filming. In fact, the whole region of Dumfries and Galloway is becoming increasingly attractive to film producers. *A Shot at Glory* (2000) will be familiar to Doonhamers and Queens fans as Palmerston Park is used as a backdrop to a sporting drama starring Robert Duvall, Michael Keaton and Ally McCoist. Duvall plays the part of Gordon McLeod, the manager of a second-tier Scottish football team owned by an American tycoon. Under pressure to stop the owner from moving it away from the town whose fans have been fiercely loyal, McLeod must bring in a new player – a player with a reputation.

Another film shot on location in Dumfries is Peter Mullan's 2002 drama *The Magdalene Sisters*. Set in 1964 Ireland, it follows three young Irish women's struggle to cope with the abuse they receive as inmates of a Magdalene Sisters Asylum for unmarried mothers. It was filmed at the Benedictine Convent on Maxwell Street. Many Doonhamers were hired as extras.

The convent, designed by London architects Pugin & Pugin at the expense of the dowager Lady Herries, was built in 1881 for the nuns of the Perpetual Adoration of the Blessed Sacrament. It sits at the top of Corbelly Hill overlooking the town. During its history it has served as a girls' school and a temporary court for Dumfries when the courthouse was being renovated.

The Theatre Royal is the oldest working theatre in Scotland. Actor-manager George Stephen Sutherland's campaign for a theatre to be built in the town had an enthusiastic response and construction began in 1790. The theatre opened on 29 September 1792. Poet Robert Burns wrote several pieces for stage performance including *The Rights of Women*

Odeon Cinema.

Benedictine Convent.

I've travelled this country from East to the West
From North to South and of walks seen the best
But no walk like the Dock of Dumfries

Col de Peyster c1800

Inscription at entrance to Dock Park.

for Louise Fontanelle when she performed in 1792. The theatre's popularity was at its highest during the Victorian period but audience tastes changed. In the 1920s it became, briefly, a roller-skating rink. Its next phase was as a cinema called The Electric Theatre until it closed in 1954. It reverted to a theatre when the Guild of Players purchased the building in 1959. Major maintenance and refurbishment took place in 2015.

The oldest park in Dumfries is Dock Park, established in 1893. A £2 million regeneration programme was carried out a few years ago and after reopening in 2014, the 22-acre riverside park was voted Scotland's favourite in a national contest.

DID YOU KNOW THAT...?

Buffalo Bill's Wild West show came to the town in 1904 and performed two shows for excited audiences. Buffalo Bill was fulsome in his praise for both the town's place in history during the time of Bruce, and for Robert Burns, 'who made the whole world kin'. Native Americans in full regalia laid a wreath at the Burns Mausoleum in St Michael's churchyard.

Long before it became a public park, the area was used as common pasture for livestock. It has been used as bleaching fields and drying greens, a parade ground for local militia, a bathing place and a romantic riverside walk. The first lime trees, which were supplied by the Duke of Buccleuch's grounds at Drumlanrig Castle, were planted in 1748 with the Duke's gardener, John Clark, overseeing the planting.

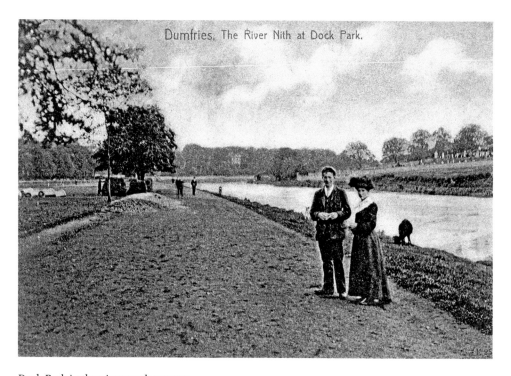

Dock Park in the nineteenth century.

As well as a children's play area – at the edge of which stand two carronades, the small cannon made by Carron Iron Co. – there is crazy golf and a maze which was built with railings reclaimed from the war.

The nineteenth-century bandstand has been restored. The café, when first built, was called the RA Grierson Rest and Recreation Room, after the Town Clerk of the time. It could only be used by men of sixty years and over who lived in the Dumfries burgh.

Several decorative cast-iron commemorative benches are in the park, dating from 1828 to 1894. In the 1850s, three of the seats, inscribed 'For the Sick Poor', came from the old Dumfries and Galloway Royal Infirmary. Others have been presented by local merchants. One 1828 bench bears the name Affleck and an 1899 one, Drummond and Son Dumfries. Nothing indicates where they were made but presumably a local foundry was used.

Castledykes Park lies between the Glencaple and Kingholm Roads. It contains traces of a medieval castle, picnic areas, tree plantings from both the nineteenth and twentieth centuries and a number of plaques commemorating people and events. A Bronze Age axe indicates there has been human activity here for some 3,000 years. There was an eleventh-century motte-and-bailey castle near the Kingholm Road entrance to the park. Towards the end of the twelfth century another castle was situated near the Glencaple Road main gate. It changed hands, was destroyed and rebuilt regularly. Robert the Bruce seized it after the murder of the Red Comyn in Dumfries. It was demolished around 1313.

In 1821, Ebenezer Stott, a successful businessman in the American cotton trade, bought Castledykes estate. With his wife Elizabeth from Philadelphia, they built an Italianate-style villa designed by Walter Newall. They paid Dumfries Burgh the enormous

Carronade (one of a pair) built by the Carron Iron Co.

The café.

The nineteenth-century bandstand, now modernised with electric points and lights.

One of the seats in the park 'for the sick poor'.

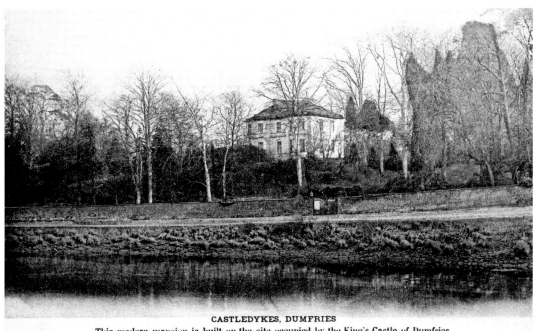

CASTLEDYKES, DUMFRIES
This modern mansion is built on the site occupied by the King's Castle of Dumfries,
all trace of which has now disappeared

Castledykes Mansion.

sum of 100 guineas for Kingholm topsoil. After her husband died, Elizabeth put the property on the market. Evidence of her enthusiasm for gardening can be seen in the sale advert, which mentions a sunken garden with fruit trees and bushes, fountains, peach house, vinery, hot house and cistern, mushroom house, forcing pit and also, on higher ground, a large greenhouse. Grapes, nectarines, peaches, apricots, pomegranates and figs were grown.

The property changed hands several times over the next few years. Subsequent owners included Robert Scott, a jute manufacturer whose son owned Nithsdale Tweed Mills, and a Dr James Bruce, who tried to blow up old tree roots with gunpowder. The Burgh of Dumfries bought Castledykes in 1901 and in 1952 the Parks subcommittee accepted administration of the estate on condition that the mansion house was demolished.

DID YOU KNOW THAT…?

Regattas have taken place on the River Nith since the late eighteenth century, most likely between crews of the ships berthed along the river. The Nithsdale Amateur Rowing Club began back in September 1865 after fourteen gentlemen held a meeting in Ingram's Coffee House to organise a regatta club on the River Nith. The Nith Regatta Club was formed, changing its name in 1890 to Nithsdale Amateur Rowing Club.

10. Curiosities, Mysteries and a Sad Story

Not many towns can boast a rhino on top of a bus shelter – especially not on top of a pretend bus shelter.

The Dumfries rhino was dreamt up by schoolchildren when asked, in the 1980s, for ideas to improve the Lincluden area of the town. With an arts grant of £1,500 local artist Robbie Coleman created the rhino, which stood majestically, if incongruously, on top of the bus shelter where it attracted a lot of attention.

It was there for years, a useful landmark, until roadworks, including a roundabout, led to the removal of both bus shelter and rhino. The rhino was left in storage (anecdotally because the new shelter had a curved roof, unsuitable for a rhino to stand on) but it had by then become so much part of the townscape it was decided to build a lookalike shelter for it and now, there's a baby rhino as well.

Made famous by Walter Scott's novel *Old Mortality*, the real-life Old Mortality was Robert Paterson, who spent his later life travelling around maintaining Covenanter grave sites. Robert was born around 1713 on the farm of Haggis Ha in Hawick and became a stonemason.

Rhino and baby on pretend bus shelter.

He moved to the village of Balmaclellan in 1768 where his wife taught in the school to provide for the family while her husband travelled ever further afield to carry out his life's work. Joseph Train, an excise supervisor, collector of local stories and artefacts, and a friend of Walter Scott, told the author about Robert Paterson. It seems Scott and Paterson did meet on one occasion, when the latter was cutting a headstone in Dunottar churchyard. Paterson died 14 February 1801 and is buried near Caerlaverock.

The statue of Old Mortality and his pony standing outside Dumfries Museum is one of several similar group statues carved by John Currie (or Corrie). Born at Loch Foot near Dumfries, he trained as a mason. In 1839 he exhibited Old Mortality and his pony in Liverpool where it was well received.

Encouraged by this he moved to Liverpool, where he worked on a group representing another two of Scott's characters, Edie Ochiltree and Douster Swivel, shown in London in 1840. Subsequent work was not so successful and in the early 1840s he returned to Dumfries. The museum acquired the Old Mortality statue through an unfortunate accident. When Currie returned from Liverpool he needed money. He sold raffle tickets for Old Mortality and his pony. An army surgeon, Dr Sinclair, won it. Unfortunately, he died in a gig accident near Chatham on the day the raffle was drawn and never knew he had won. On behalf of his family his executors presented the work to the Dumfries Museum.

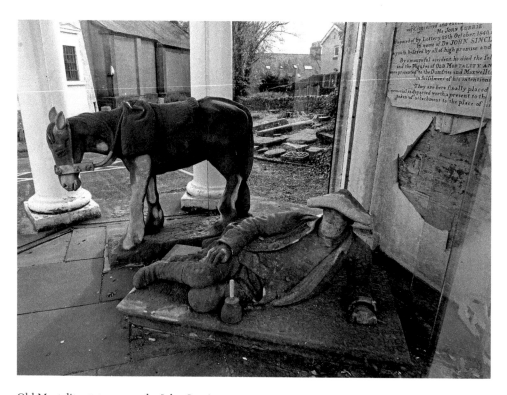

Old Mortality statue group by John Currie.

Currie remained in Dumfries working from a studio at No. 130 High Street. He carved the figures flanking the main entrance to Nithbank, when it was the Dumfries and Galloway Royal Infirmary. They are of Aesculapius, the Greek and Roman god of the medical art, and his daughter Hygeia, goddess of health.

We have not been able to solve the mystery of a 'standing stone' and other stones, engraved with coats of arms and marriage slabs with inscribed initials, in an area above Mill Road, reached by a flight of steps. Nothing definite is known about the 'standing stone' other than it has been repositioned there. It may have been used as part of a fireplace lintel.

It seems the carved stones were removed from the late medieval town houses of Maxwelltown that were demolished in the 1960s to make way for the current flats. A lot of demolition work took place around what was the core of the medieval settlement. We know that Alf Truckell carried out a lot of excavation work on demolished buildings, so perhaps he arranged to have the stones placed there.

Around Dumfries the land is littered with prehistoric sites from Bronze Age burial sites to cup and ring markings. The Twelve Apostles, the largest stone circle in mainland Scotland, is only a couple of miles from the town.

Above left: Aesculapius, Greek god of medical art, at Nithbank.

Above right: Hygeia, goddess of health. Both by John Currie.

The mystery 'standing stone' above Mill Road.

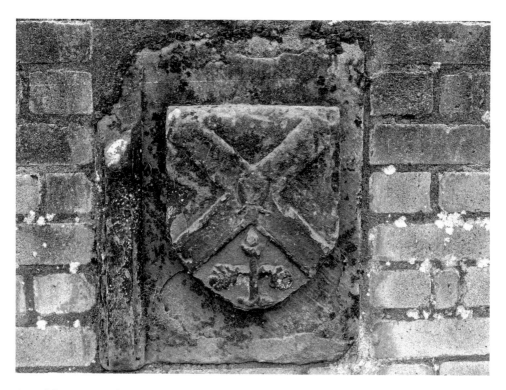

One of the stones with carved crest.

A stone carved with marriage initials.

One Druid circle, however, is not what it seems. Half a mile from Friar's Carse Hotel, a few miles from Dumfries, on a hilltop is a stone circle. Although the trees make it difficult to see it in its entirety, the circle is around 31 metres in diameter with some thirty-three stones ranging in height from 1 to 1.5 metres with a 1.8-metre pillar in the exact centre. Outside the circle is a rectangular cist.

The circle is a folly created by Captain Robert Riddell (or Riddel), an enthusiastic antiquarian, when he owned Friar's Carse in the eighteenth century. During the seventeenth and eighteenth centuries there was an obsession with building follies: from towers to classical ruins.

The authenticity of the circle, though, has fooled people over the years – and possibly still does. Alexander Thom, famous for his studies of Stonehenge and other megalithic

'Druid' circle at Friars Carse.

sites, surveyed the circle in 1939. He said, 'This is reputed to be a fake but we believe it to have been an original megalithic site. The workmen who re-erected it could not have determined the azimuth of the small cist within 0.2 degrees of due east.' In 1948, naturalist W. Balfour-Browne said, 'it is now so weathered as to take in anyone. It should be a warning to all antiquaries'.

Even though the stone circle is a fake it has been built on top of a genuine Iron Age fort with moat banks and ditches, and although the circle only appeared in the 1780s its stones are ancient. No one, however, knows from where Captain Riddell took them. Similarly, a medieval cross standing outside the hotel is another mystery – a genuine cross but, again, not belonging to Friar's Carse.

DID YOU KNOW THAT...?

On the first Monday in May, the Muckmen (the refuse collectors and road cleaners) paraded through the town on horseback, 'armed with swords and dirks, and bedizened with sashes and ribbons'. They then 'brought in the Simmer' by riding out to Dalskairth Woods near Dumfries and bringing back leafy birch branches. A race followed for the silver muck-bell. The winner was not allowed to take possession of the bell, which remained in the keeping of the burgh, but received instead a cash prize. Accusations of 'irregularities and misdemeanours' led to the council abolishing the custom in 1716.

When we started researching for this book we quickly discovered the hottest topic on local Internet forums is the question of secret tunnels running under the town. We asked for information and were inundated with anecdotes about underground tunnels: tunnels from the old Greyfriars Monastery to the convent at Lincluden, tunnels under Crichton Hall to the crypts of the church, tunnels under the High Street and the Vennel. Someone pointedly remarked on a forum, 'If all these tunnels existed the town would have collapsed.'

We consulted archaeologists and archivists hoping to find a definitive answer. There is definitely not, and never was, a tunnel from the town to Lincluden. We looked up dictionaries for definitions. A tunnel, secret or otherwise, is an artificial underground passage with an entrance and exit at either end, especially built through a hill or under a building, road, or river.

Bearing that definition in mind, there was a tunnel under Buccleuch Street which was used to escort prisoners from the old courthouse to the jail on the corner of Irish Street. The existence of a tunnel on Greyfriars Street was discovered when repair work was done on the steps of a house. Both the house and the buildings opposite were owned by a businessman in the late eighteenth or early nineteenth century who presumably had the tunnel constructed between his home and his business.

A genuine tunnel ran from under this building across the road to business premises on Greyfriars Street.

A vault is a room or space, such as a cellar or storeroom, with an arched ceiling, especially when underground. The 'tunnels' reputedly under the town centre, Queensberry Square, are most likely vaults of the New Wark, the massive fortified tower house built by Sir Herbert Maxwell in 1440. Similarly, beneath the Vennel the blocked-up 'tunnels' are mostly likely vaults, now inaccessible.

The tunnels that possibly cause the most debate are those relating to the Crichton. In 2016 there was great excitement when workers installing broadband cables uncovered a 1.8-metre-wide structure near the Easterbrook Hall. No one seems to know exactly what it was. One theory is that it may be what was known as the Cinder Path, which ran from Brownhall to a small gate near the Grierson Gate.

George Turner mentions it in his book *The Chronicle of Crichton Royal 1937–1971*. George was brought up on the Crichton where his father was coachman. Writing about the site as it was in the 1930s and early 1940s he says there were 'gates on either side of the public right-of-way at the top of Brownhall Loaning. The right-of-way continued to Bankend Road via the Cinder Path which was enclosed by high spiked railings.' Describing the site as it was in 1968 he writes, 'The enclosing iron fencing of the east/west public right-of-way is of no utilitarian use at the present time. The removal of this fence and infilling of the sunken path would enhance the appearance of this area of the grounds.' A little later, in 1968, he reports, 'the old right-of-way has been filled in'. Underground tunnel or infilled Cinder Path? The jury is still out.

A passageway in the basement of Crichton Hall: one went to the laundry, this one to the old boardroom.

We were privileged to be allowed to do a bit of exploring in the basement of Crichton Hall – an opportunity to seek out those much-talked-about tunnels. We saw the wine cellars for wealthy patients and the stairs which ran from the basement to the top storey. The configuration, with the stairs running between two cylinders with a doorway at each level, was designed to prevent patients committing suicide. The stairs were so dark that gas lighting burned all day.

We did not find any tunnels – passageways, yes, but no tunnels. A passageway is a long, narrow way, typically having walls either side, that allows access between buildings or to different rooms within a building. Passageways led, for instance, to the old boardroom and to the laundry, but they are not tunnels.

Our last secret story is a sad one though it is also a story of friendship and loyalty. The riverside walk, heading upstream, passes behind the public toilets and under an arch of the Buccleuch Bridge. Keep your eyes peeled for a tiny (not much bigger than a matchbox) plaque on the left wall. Not many people will ever notice it. All it says is 'Derek Styles (Tinker)' and the dates '17-10-61 TO 13-7-13'.

It took a while but we learnt who Tinker was and the story behind the plaque. Tinker had been with the 2nd Battalion of the Parachute Regiment in the Falklands and had taken part in the battle for Goose Green in May 1982. It was a battle that involved the Paras using bayonets as well as bullets and phosphorous grenades. Tinker was twenty-one. Whatever he experienced and witnessed changed him forever, as it did many others.

The memorial to Tinker.

Mark Frankland, who runs Dumfries charity First Base, knew Tinker through the charity's Veteran's Project. When Tinker died he wrote about him on his blog:

He carried a sadness about him like a tired old overcoat. His fifteen minutes of fame wrecked his life. Was Goose Green to blame for his premature passing? Of course it was. Before Goose Green he was a super fit young guy who represented the Army in gymnastic tournaments all over the world. A bright future was waiting to be walked into. After Goose Green, nothing was ever the same again. His life was a shell of a life. A long, dismal road where drink and drugs stripped away his health and self-respect and the nightmares came at him every night.

People may think they didn't know Tinker but he was a familiar figure selling the *Big Issue* on High Street – and he always sold every copy. Shortly before he died, he asked Mark for a referral to a programme at Combat Stress, but we'll never know if it would have helped. He died before he was offered a place. He died before he reached the age of fifty-two. Mark describes Tinker as 'a quiet man. A decent man. A man with genuine morality. Empathy. Humanity'. His friends share that opinion and one, Gary, arranged for the tiny plaque to be put under the bridge so that Tinker would never be forgotten.

Bibliography

Baldwin, Jayne, *The Road to the Gallows* (Stranraer: Clayhole Publishing, 2013).

Burl, Aubrey, *A Guide to the Stone Circles of Britain, Ireland and Brittany* (Yale University Press, 2005).

Carroll, David, *Dumfries & Galloway Curiosities* (Stroud: The History Press, 2013).

Carroll, David, *The Dumfries Book of Days* (Stroud: The History Press, 2014).

McDowall, William, *History of Dumfries* (Dumfries: T. C. Farries & Co., 1986 edition).

Rinaldi, Giancarlo, *Great Dumfries Stories* (Ayr: Fort Publishing, 2005).

Ward, Christopher, *And The Band Played On* (London: Hodder & Stoughton, 2012).

Websites:

Wilson James, *Biography of the Blind* (1836 edition)
www.archive.org/stream/biographyofblind00wilsuoft/biographyofblind00wilsuoft_djvu.txt
www.futuremuseum.co.uk

Acknowledgements

We owe thanks to many people who have helped us in various ways. Morag Williams, former archivist at the Crichton Museum, has a wealth of knowledge, not only about the Crichton but about Dumfries history in general – and if she doesn't have the answer she can call on an extended network of history detectives.

Graham Roberts, archivist with Dumfries and Galloway Council; Andrew Nicholson, Dumfries and Galloway Council's archaeologist; and Joanne Turner, Museums Officer, Dumfries Museum and Camera Obscura answered our many queries and signposted other areas for research. Ian Bryden, Head of Estates and Property NHS Dumfries and Galloway, allowed us to visit the basement in search of tunnels.

Thanks goes to Kathleen Cronie and her Mostly Ghostly team who introduced us to some fascinating people in St Michael's churchyard and to the many followers of Old Dumfries Facebook page for anecdotes and enthusiasm for the book. I am grateful to editor Lynn Watt for proofreading, but more importantly, for saying she found *Secret Dumfries* interesting.

Picture Credits:
Images courtesy of the Dumfries Museum and Camera Obscura: The Siller Gun, Miss McKie's burgess casket, Robert Smith death mask, the Mary Timney broadsheet and the photo of Robert Louis Waland
Moat Brae roof dome: Colin Hattersley
Infectious Diseases Hospital gatepost: Allan Devlin
Death of Comyn (portrayed by Felix Philippoteaux): public domain

About the Authors

Mary Smith is a writer, freelance journalist and poet based in Dumfries and Galloway. Two of her books, *No More Mulberries* and *Drunk Chickens and Burnt Macaroni*, are set in Afghanistan where she worked for several years. *Thousands Pass Here Every Day* is a poetry collection and her latest publication is *Donkey Boy and Other Stories*, a collection of short stories. She has worked on two other Amberley titles: *Dumfries Through Time* and *Castle Douglas Through Time*. She enjoys local history research and walking in the wonderful Dumfries and Galloway countryside.

Keith Kirk is Galloway born and bred. He is a former local countryside ranger with over forty years' experience. As well as his award-winning photography, he now owns and leads the tours for Nocturnal Wildlife Experience. Keith is more known for his beautiful wildlife and landscape images, but does turn his attention to other subjects, as this book shows. He also writes a monthly wildlife article for *Dumfries and Galloway Life* magazine as well as a monthly Nature Notes column for the *Galloway News*.